Advance Praise

The Culture of Possibility: This title alone opens doors, and Arlene Goldbard offers more on every page. By showing us that culture is the crucible in which we forge our laws and our government as well as our values and families, she restores our power as unique individuals and as creative communities. The idea that all change comes from the top is the propaganda of those who wish it were true. This book encourages us to take back our power through unique and communal creativity.
—Gloria Steinem

If we're going to end this fiscal madness and start rebuilding America, we're going to have to get creative! We need a tsunami of music, film, poetry and art. *The Culture of Possibility* shows us how creativity can take our story back from Corporation Nation, tilting the culture towards justice, equity, and innovation. I urge you to read this book!
—Van Jones, Rebuild The Dream

The Culture of Possibility potentially will change the way we think about culture and the arts. Arlene Goldbard clearly challenges our understanding of culture as "the operating system" through which we label social issues, while suggesting that it is through the arts that meaning or beauty gives "shape to concepts and feelings." Goldbard is brilliant in her argument of "Hidden in Plain Sight" in which she uses the parables of "Datastan" versus "Republic of Stories," social systems built on a linear, machinelike approach versus storytelling which augments reality through nuance, imagination, and empathy. This comparison equips the reader with critical knowledge about the world and the potential for the future. I did not find this book to be prescriptive. On the contrary, it is filled with language that invokes an understanding and appreciation of the enormous opportunities for artists to illuminate the Enlightened of "the culture of possibilities."
—Raymond Tymas-Jones, Ph.D., Associate Vice President for the Arts and Dean, The University of Utah College of Fine Arts; former President, the International Council of Fine Arts Deans

Run, do not walk, to read *The Culture of Possibility*. This clear-eyed, deeply informed, profoundly optimistic vision of the true power of the arts provides a fresh framework for all those in the arts, for those who love the arts, and for a much wider audience, including those who care about a healthy democracy, social justice, and the fabric of U.S. culture—because Goldbard reminds us of truths we know experientially but have lost in the status quo patterns of arts organizations and advocacy. Read the book. Give it to your friends (who will thank you). Discuss it. Because *The Culture of Possibility* presents us with vivid and visceral understandings with which to engage an arts-peripheral nation in the centrality of our human artistic birthright and brimming cultural potential.

—Eric Booth, educator, author, senior advisor to El Sistema

For decades, Arlene Goldbard has been an inspiration to arts workers for cultural democracy. *The Wave* and *The Culture of Possibility* bring together in two forms the wisdom and critical intelligence that have shaped her thought. They offer a "buffet" (food and music are integral parts of her life) that should give indigestion to those devoted to the status quo and stomach-patting fulfillment to those working toward a "conscious cultural revolution." She brings to bear a rational, compassionate activism on the most pressing issues facing our society. Both books combine astute analyses and thought-provoking gems with a real sense of hope. Both books are dialogues, and I'll bet that most readers won't be able to resist talking back.

—Lucy R. Lippard, author of *The Lure of the Local*

In the more than 30 years that I have known her, Arlene Goldbard has been a consistent and formidable cultural warrior—intensely brilliant, articulate and full of good humor. Now she comes armed with a double-barreled shotgun—two companion works, *The Culture of Possibility*, a brilliant argument for the critical role and nature of art and culture, and a novel named *The Wave*, referred to as 'speculative fiction,' examining what would be required and what our world might be like if art and culture were elevated to primary importance. There is much new, fresh thought here, and more, an entire world view that anyone seriously concerned with either category should read.

—Peter Coyote actor, author, *Sleeping Where I Fall*

THE CULTURE
OF POSSIBILITY:
ART, ARTISTS & THE FUTURE

THE CULTURE OF POSSIBILITY:

ART, ARTISTS & THE FUTURE

ARLENE GOLDBARD

Arlene Goldbard

To Steve,
with all
good wishes,

Arlene

The Culture of Possibility: Art, Artists & The Future
Arlene Goldbard
Waterlight Press
www.cultureofpossibility.net

Library of Congress Control Number: 2013937647
ISBN-10 0989166910
ISBN-13 978-0989166911

Contents

Read This First
A Brief Tour of The Culture of Possibility: Art, Artists & The Future

Try to remember the earliest moment in your life that was illuminated by art, the time when you first took it seriously. For me and so many people I know, what comes to mind is the personal discovery around the time of puberty of music's power. Think how it felt—at the end of a day filled with longing for love or belonging or mastery, rejoicing in its imminence, despairing at its flight, enduring all the attendant self-questioning—to lie on your bed filling your head and heart with music that spoke as urgently as the voices of hope and doubt echoing inside. Think about the way the music moved into every part of your body, how it enlivened and excited your feelings, thoughts, your sense of connection with something larger. Think about the excitement of calling a friend to share new music or a new film, a new dance-step. Think about the magical way that these discoveries showed you more of yourself, activating your imagination and desire, propelling you along the path to becoming.

Throughout my life, when I ask myself where I have felt most whole and present, most connected, the answers are infused with the multidimensional force of art. Music is there for me always: music is playing now as I write, and while my hands maintain their pose at the keyboard, other parts of my body are swaying softly in time. A shimmering portrait of the musicians hovers just behind my eyes, a gossamer scrim of memory and imagination. I am alone, but the music activates a sense of integration that multiplies presence. Perhaps

the music summons the spirit of its creators; perhaps it is just that all my selves settle into congruence as I listen, that the music calms and unites them.

I've had the same feeling facing a museum wall and allowing myself to disappear into a painting's field of shape and color; willing energy through my body and out the tip of the pen with which I am rendering a friend's face or a just-plucked geranium leaf; noticing my mounting excitement as I watch a film that seems to contain a secret worth knowing; wanting a novel never to end. Whatever else was happening at the same time—celebrating a holiday, making love, cooking dinner, walking in the woods—the experiences that have most excited my imagination, activated my empathy, illuminated my world, and connected me with others have been infused with art.

Why are these peak moments of making and experiencing art shrunken in the conventional estimation to the scale of trivial detail, to meaningless frills on the social fabric? As you will read in this volume, in these waning dark ages conventionally called modernity we have been asked to accept an understanding of life as bounded by getting and spending and a social order shaped for the convenience of machines and those who benefit from treating us like machines. We are living with the consequences of this radical diminishment and they are not pretty. The steady doom beat of the mass media is powerfully discouraging. Abandon hope, it says, our problems are too many, too complex, too far gone to be solved. Cede your judgment and autonomy to the people in charge, we are told. (Ignore the fact that they created this mess.) Go about your private business. Buy something distracting.

Surprising as it may seem, hard as it may be to accept, the opposite is true. If you begin to see culture clearly, everything changes from despair to possibility. Reconnect with those peak moments and you will understand that culture is the matrix of any humane society, the power-

source of the imagination, empathy, creativity, and resilience needed to activate our innate capacity for moral grandeur and social healing.

What would it be like to turn off the abandon-hope soundtrack, to recall with full force what you have already learned from direct experience, to effect the simple switch in perspective that can change everything? I can tell you that it brings relief, a profound liberation from the disheartening view of our current predicament as a conundrum without exit. I know that it can free a mind from the grip of a worldview that no longer serves, that it can break the dam erected by those who benefit from others' resignation, that it can release a flood of new possibility. In *The Culture of Possibility: Art, Artists & The Future* I invite you to try it on and find out for yourself.

I see something, and I want you to see it too. Written between the lines of received reality is a much more colorful, exciting, and possible world. In this new world, beauty and meaning occupy their rightful place as the force that drives civil society, and culture is the laboratory in which we discover how to improvise a livable future. I want you to see it because it can enlarge perspective and therefore life. I want you to see it because it is an emergent truth that will be propelled by your awareness: the more people who see it, the faster things will change. I want you to see it because if enough people see it, that will catalyze the collective shift in perspective that will validate hope—not just whistling in the dark, but hope grounded in reality.

Art and Culture: What Does She Mean By That?

Throughout this volume, I use two words that are perpetually contested. By *culture*, I mean the fabric of signs and symbols, language and image, customs and ceremonies, habitations, institutions, and much more that characterize and enable a specific human community to form and sustain itself.

Culture is an elastic idea, accommodating all that we human beings create. Look around you, skipping over everything that comes under the heading of "nature"—the sky, the trees with their dappled leaves, the rush of waters, the birds flying by. Whatever you see or hear that doesn't fit the category of nature, all of that is culture. It is the sum-total of human creativity and invention: language, signs and symbols, systems of belief, customs, clothes, cooking, tools, toys, and adornments, everything we build and everything we use to fill it up including art, the concentrated essence of culture.

But often the word is deployed in a slightly narrower sense, to indicate those things that seem distinct, part of the unique pattern that enables us to distinguish one human community from another: you could say *Jewish culture* or *Italian culture* or *geek culture* and each rubric would conjure such a pattern. If the available information were granular enough, a very specific pattern would be evoked: Russian Jewish culture, Venetian culture, or Google's corporate culture. Culture is also used in a still-narrower sense, as in *East Village cultural life*, which is likely to call to mind the aggregate of arts activity in that neighborhood, the sum total of concerts and exhibits and screenings and workshops and so on. As you read on, the particular usage will be evident in context.

There are few communities on the planet isolated enough to confine members within the bounds of a single culture. Nearly everyone experiences some form of multiple participation, multiple belonging. I partake of the common culture of the United States: I know a good deal of its holidays and customs, something of its official (and unofficial) history, language, institutions, and default assumptions. I am also embedded in Jewish culture, sharing a body of knowledge and customs with many of my fellow Jews. With friends and colleagues who also came up in the 1960s, there's a shared membership in that era's counterculture grounded in common values and practices, a collective set of experiences that constitute a sort of lingua franca. And I could go on listing. With

few exceptions, culture isn't a matter of either/or, of hard-and-fast boundaries, but of permeable membranes exchanging influences that help to shape the whole.

That doesn't render cultural distinctions meaningless, but we do tend to discuss them as if they were solid and precise when in actuality, few are. For instance, we have many ways to name the categories of difference widely recognized as significant in this country: race, gender, ethnicity, sexual orientation, physical ability, religion, and so on. But even though I've assigned to myself the category "Jewish culture," I may share very little with many others who also accept that categorization: an ultra-Orthodox man in Jerusalem who is affronted by the insubordinate behavior of a woman such as myself, a young Russian who lacks even elementary knowledge of Jewish heritage, and so on. Our cultural landscape is littered with clumsy assumptions based on these top-level categories. We think we know a lot about people from just a few words. But reality is much more various and subtle: while no African American will have come to adulthood without facing racial discrimination and no woman of any color or heritage will have escaped condescension or threat on account of her gender, for both categories, class and other conditions are just as important in shaping formative experiences of inclusion and exclusion.

We tend to see social issues as unitary and definitive: racism is one problem, sexism another, Islamophobia distinct from Antisemitism, and so on. All true from the perspective of those oppressed by discrimination, who are made by their oppressors to understand that they are being singled out for punishment on account of specifics of race, sex, or creed. But all of these notions interact, reinforcing or contradicting each other, thus engendering a pervasive social condition. To comprehend that, pull back the lens and look at culture. The idea that some groups are more worthy than others is embedded in culture; the idea that the members of some groups are entitled to make such pronouncements is embedded in

culture; the idea that we can discern something truly meaningful about others through such broad categories is embedded in culture. Culture is the operating system; racial and gender-based discrimination are just particular pieces of malware it supports.

By *art*, I mean those artifacts and experiences intentionally created to convey beauty or meaning, giving shape to concepts and feelings. The category encompasses painting, sculpture, photography and other visual arts; poetry, fiction, and other literary arts; theater, dance, music, and other performing arts; moving-image media such as film and television; digital media; and increasingly, work that transcends and subsumes many of these categories and so can't be slotted into a conventional discipline category. Some artwork is unique and handmade; some is mass-produced. Some is marketed and sold; some free for the taking. Some is made by an individual; some a collective creation.

When I write of *artists*, I mean the people who create these objects and experiences. By community artists, activist artists, socially engaged artists, I mean makers of art in collaboration with other community members as a collective expression, often one that calls attention to injustice or celebrates commonality.

Art is a neutral, descriptive term, not a qualitative judgment. The person who asks, *But is it art?* is making the error of treating "art" as a synonym for "likable," or "excellent" or "well-executed." If a particular work's merits are being called into question, fine. Perhaps you don't like it, or I don't see it as reflecting a committed intention or coherence—for any reasons we choose, either of us may pass it by.

But when a work's status as art is questioned, something else is almost always at stake: should this work be underwritten by a grantmaker, performed on a stage or exhibited in a gallery, should it be screened or broadcast? Should it be taught as part of the canon (leaving aside whether a canon should shape teaching or not)? These are gatekeeper questions. All of them can be replaced by a single question: do I want to

give my attention and support to this work? The answer to that question is up to the asker, but if the makers say it's art, it's art. Why not?

How We See

What you see is what you get. This assertion is so commonplace that it has its own abbreviation. WYSIWYG describes a computer program's user-friendly interface; it is a popular headline for online dating profiles, where it signals having nothing to hide; it was a 1971 hit for Stax recording artists The Dramatics ("Whatcha See Is Whatcha Get"). It also works very well as a description of human perception. Regarding the identical image, the identical words, you and I may take away markedly different messages that will shape the divergent thoughts, actions, and feelings conditioned on whatever we perceive.

I want you to see what I see. I know it is not the only way to look at the world. But I have no doubt that adding this perspective to any repertoire of worldviews will add value to the whole. I want to assist you in getting your arms around it, and to do that, it helps to look at what you already believe and how those beliefs act on you.

For instance, cognitive scientists say that our minds are shaped by ancient circumstances that promoted rapid diagnostic skills. Our earliest ancestors survived in part because they were able to perceive danger before it caught up with them. We are skilled at forming quick hypotheses about the meaning of whatever we see, drawing on a backlog of experience and selecting for enough similarities to improve our odds of being correct. But confirmation bias is also built into our minds. Out of the vast amounts of information available at any moment in our information-rich world, we humans beings are prone to select whatever confirms what we already believe, then disregard the rest. We have an inbuilt tendency to see what we expect to see, and as everyone knows, even the smartest people are often wrong.

This error functions on both the most basic level and the most complex. I squint at a shape making its way toward me across a field: a horse, a cow—I'm absolutely sure it's a horse—until, no, it's a boy hunched low on a bicycle. Instant reactions to new acquaintances often turn out to be rooted in reminders: the new person resembles a beloved friend or someone who did me harm, and until actual knowing replaces the application of a template, that person is clothed in borrowed feeling. We debate the issues of the day, heaping up evidence that corroborates a position that may well be a priori, conditioned on gut feeling or instinct; we feel validated when the volume of corroboration swells, but unless we are aware of this tendency and consciously correct for it, we seldom trouble to give due consideration to contradictory evidence.

Where we put our attention also influences what we see: more than six million people have viewed the "Selective Attention Test"[1] on YouTube, based on an experiment devised by cognitive scientists Daniel Simons and Christopher Chabris. Viewers asked to count how many times a basketball is passed generally miss the fact that a gorilla walks through the game. Consensus reality—what "everybody knows"— cultivates a form of selective attention, asking us to focus on what is commonly agreed to be the foreground of experience. But if we comply, we miss a great deal of useful information.

Just so, I wrote this book to show you something that lives in plain sight, but which many people cannot yet perceive because it is not what they expect to see. You could say that their potential consciousness is limited, with conventional wisdom standing in the way of perceiving what is actually before their eyes. Their understanding is already occupied by received notions, stubborn little squatters determined to maintain a foothold in their minds, leaving no room for a new view.

1 http://www.youtube.com/watch?v=vJG698U2Mvo

So What?

So what? Just this: our capacity to act is conditioned on the story we tell ourselves about our own predicament and capabilities. The human project is at a precarious pass. We are being warned that life itself is at stake due to climate change humans have caused, yet those who profit in the short term from non-renewable energy expend tremendous effort and capital to obscure the truth and discourage remedial action. The United States' polarization of wealth is very likely to produce suffering far beyond that already seen from the subprime mortgage meltdown and chronic, epidemic unemployment. The resulting tension is merely the domestic version of North versus South fostered by globalization. In the U.S. today, immigrants and their descendants are demonized, women's health is sacrificed to a political agenda, a remarkably high proportion of children live in poverty with substandard education and healthcare. Political discourse is polarized too, marked by utter incomprehension between the poles of opinion.

The official—the institutional, dominant, or conventional—view of these social challenges is as distorted as a funhouse mirror. Possible solutions are deeply constrained by existing power relations: what useful response to climate change can be devised if it is required to please oil companies and auto manufacturers? What useful response to ballooning poverty can be devised if it is constrained from taxing wealthy corporations and individuals to benefit those most in need? What useful response to racial injustice can be devised if naming those who profit from white supremacy is foreclosed as impolitic?

To see clearly in a time of rapid and unsettling change is a survival skill. Persisting in viewing the world through a distorting lens of expectation means missing real danger and real opportunity, at our peril. A radically new perspective is needed, one that can bring the full force of human creativity to bear on these challenges. Facing our situation is the prerequisite to imagining, improvising, to allowing feelings as well

as thoughts to emerge, to seeing deeply, telling truth, making full use of every talent and every energy at our disposal.

To even begin to conceive responses worthy of current challenges means removing all barriers to clear sight. For me, this translates into a simple proposition. We need to learn to see like the most committed and skilled artists: eyes wide open, taking it all in, turning away from nothing, cultivating empathy and imagination, venturing forth, taking risks, admitting mistakes, persevering.

Toggle Vision

In that effort, certain mental devices may be helpful. If one works for you, it's yours. If not, just skip it.

For instance, consider optical illusions. When Thomas Kuhn, who wrote the influential 1962 book *The Structure of Scientific Revolutions,* wanted to explain what he meant by a "paradigm shift"—a periodic change in scientific consensus such as replacing an Earth-centered universe with one in which the Earth revolves around the sun—one analogy he used was an optical illusion.

In a paradigm shift, it isn't the world that changes, but how we see it, the story we construct to describe it. Indeed, just as in an optical illusion, the same information can have two completely different meanings depending on one's framework of understanding.

Remember your first encounter with an optical illusion? Mine was the one that toggles back and forth between a goblet and two facing profiles.

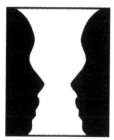

Remember how the image seemed indelibly inscribed on the page, an ordinary picture? How frustrated you felt when your companion said of the hidden image, "Look, it's right there, don't you see it?" How hard you strained to un-see the profiles, willing the goblet into visibility? How thrilling it was when you were able to see both sides of the illusion? How much pleasure you got from flipping between the two?

One way to look at the change in understanding I am advocating is as the conceptual equivalent of that exercise in visual perception. Contemplating our world, we stare at a picture, a consensus reality that appears fixed—what's real is real, right? But that's an illusion. Other, very different pictures are embedded in the way we now live. To see them, as with an optical illusion, figure and ground must be flipped.

In the conventional picture, the figure consists of those things deemed worthy of serious attention. Today's front page features a financial scandal, a hospital scandal, election campaign news, a couple of major criminal trials, changes in the government of a Mideast nation with strategic importance to world powers, and a huge sports competition. All interesting to many readers, no doubt. Most have implications beyond the mere recounting of a disturbing story. Almost all the stories are told in terms of measurable impacts: the scandals are remarkable because so much money is at stake; the sports events generate impressive scores; the campaigns break contribution and expenditure records. Apart from VIPs and major wrongdoers, people are treated as categories, and events are seen as affecting us by category: women tend to feel this way, men respond that way, African Americans this way, whites that way, and so on, all extrapolations based on survey samples. The rest of lived experience becomes background to these figures—the trivial stuff that happens while the headlines are being made.

In the new picture, figure and ground are flipped. Culture counts, how individuals feel about things counts; quantification has many

uses, but it is understood that the human subject cannot be portrayed with a palette comprising only numbers. The narratives that shape and support worldviews—the tangle of ideas, values, images, stories, and propositions that Paulo Freire has characterized as an epoch's "thematic universe"—are given proper attention, occupying the foreground. Receding into the background are the busy competitions, chatter, and inside-baseball that mostly passes for news.

If your mind rebels as you read this proposition, if you can't bring the new picture into focus, just remember that you may have to stare at the profiles for quite a while before the goblet comes into view. Give it some time, and the click will happen.

Datastan and The Republic of Stories

Another device that may be useful is to regard the two main paradigms as the conceptual equivalent of two different countries. One is Datastan, a world in which everything that counts can be counted; the other, The Republic of Stories, a world in which everything carries a story and all the stories matter. In the first realm, art and culture are trivial— entertaining, perhaps, but in the end, nice but unnecessary. In the realm that's hard to see if you are committed to Datastan's perspective, culture is the secret of survival, the connective tissue of the body politic, the matrix in which we cultivate identity, work out shared meanings, and fashion any hope of a *modus vivendi*, of a livable future.

Using the device of Datastan and The Republic of Stories works for me. I find it easy to think in terms of two conceptual realms that coexist. In my mind's eye, I see them shimmering in and out of focus, the way perspectives change when you adjust binoculars to shift between the near and far horizon. But some people can't help seeing them as either/or. They start asking me questions like this: "Does war belong to Datastan or The Republic of Stories?"

The answer is both, of course. Everything has its story: vicious propaganda is just as much a story as is a consoling tale of our ancestors' forbearance. Just so, all information is data: when I cite the size of the National Endowment for the Arts' budget versus our expenditure on war, I am using data to support my point about national cultural priorities. Datastan and The Republic of Stories describe two different ways of looking at the same information, not two mutually exclusive categories such as black and white that melt into gray if a drop of one intrudes on the other. The difference between them turns on what counts most in each paradigm.

This kind of thinking is common to non-dual spiritual teachings which often make reference to two states described as *big mind* and *small mind*. Small mind lives in the material world with all of its distinctions. Despite the pain of seeing distinctions, this is a good thing insofar as it supports life-saving discrimination: I am not the truck rushing down the highway, and if I fail to recognize that, I won't be me any more either. Big mind recognizes the extent to which everything is part of a greater unity: all connected, all holy. Both minds experience the same realities, but in markedly different ways. Both are attainable by the same human subject, simply by switching perspective.

My friend Rabbi Michael Lerner has a teaching he offers to people who find themselves mired in conflict with questions of belief. Space in their minds is occupied by an inherited image of God the father, a powerful male figure with a long white beard. They can't accept the notion that a supernatural patriarch operates the universe's control panel, so every time they hear the word "God," they pick a fight with the image in their minds. As any student of comparative religion will attest, there are almost as many notions of divinity as minds to host them. Many of these ideas make no reference to human form (let alone gender), instead employing divine names to indicate ineffable, immaterial forces that sustain the universe. "The God you don't believe

in," Michael tells them, "doesn't exist." This can incinerate a straw-man argument, the kind that is conditioned on defining something in a way that makes it easy to reject. It can invite an ah-hah! moment in which releasing a grip on an idea that no longer serves creates space for something more satisfying to take its place.

If you don't like holding Datastan and The Republic of Stories in a kind of encompassing simultaneity—as two ways to look at the world, rather than two bins for sorting it out—don't waste time arguing with it. The paradigm shift is real no matter how it is named. Just find a way to characterize it that works for you.

Two Paradigms, Named Or Not

However you wish to name it, in the old paradigm, our collective priorities are shaped by a mechanistic worldview that privileges whatever can be numbered, measured, and weighed; human beings are pressured to adapt to the terms set by their own creations. Within that paradigm, macroeconomics, geopolitics, and capital are valorized. They form the figure, the primary image of the world as depicted by powerful institutions: banks, militaries, energy corporations, major news media. People are expected to make sacrifices for profit-margin, to go to war for oil, to accept environmental damage that threatens future generations, often for no palpable reward beyond "improved economic indicators." Within the old paradigm, everything else is background: how we feel, how we connect, how we spend our time, how we make our way and come to know each other—these are all part of the scenery.

In the new paradigm, upending the composition gives things their true value. The movements of money and armies may receive close attention from politicians and media voices, but at ground-level, we care most about human stories, one life at a time. Our deepest debates, our obsessions, our consolations, and our most purely discretionary choices about where to deploy our resources and attention are conveyed

through sound, image, and movement, in the vocabulary of art. People care passionately about how they and the things they value are depicted. They revive themselves after a long workday with music or dance, by making something beautiful for themselves or their loved ones, by expressing their deepest feelings in poetry or watching a film that never fails to comfort. In the new paradigm, it is understood that culture precedes economics and politics; it molds markets; and it expresses and embodies the creativity and resilience that are the human species' greatest strengths.

In the old paradigm, humanity is stuck. Responses to our problems are constrained by conventional wisdom, which says we can't abandon or disrupt the orthodoxies and assumptions undergirding the existing order of things. By the time an issue is prepared for public consumption—by the time that dueling positions have been extruded like so much media sausage stuffed with empty platitudes—there is very little room to move. This is depressing. I wonder what else is on TV?

In the new paradigm, our prodigious powers of imagination open portals to the future through alternate scenarios that respond to social conditions, but are unconstrained by orthodoxies. There are multiple sides to every story, and many stories lead to something worth trying.

The bridge between paradigms is being built by artists and others who have learned to deploy artists' cognitive, imaginative, empathic, and narrative skills. The bridge is made of the stories that the old paradigm can't hear, the lives that it doesn't count, the imagined future it can't encompass.

How Did We Get Here?

Leafing through the book of the world—our grand narrative, the one that contains all of our individual stories—it's easy to see how we have been conditioned to accept the old paradigm as natural and inevitable. For a long, dry time, we've been sold a story in which machines—their

forms, logic, and interchangeability—play the protagonist. Those who shape our largest institutions have been seeking ways to make human beings behave evermore like machines, blending coercion and persuasion to promote conformity to inhumane systems. This has been a challenge, given our species' prodigious unpredictability and diversity. They've prized efficiency, defining value through quantification. Conventionally, we teach to the tests, employ human resources instead of human beings, train each other to accept long, frustrating interactions with programmed voices, to adapt in countless ways to serve the systems that ostensibly exist to serve us. We are repeatedly told this is for our own good, even that it is the natural order of things, the product of something like evolution. Many of us have absorbed the idea that resistance is futile; our only choice is to adapt.

The social model I call Datastan has evolved over centuries, arguably driven by the worship of our own creations that gathered force in the Industrial Revolution. But it took the twentieth century to lend it an air of timeless permanence. We were persuaded that it made sense to replace jobs with automation wherever possible. Datastan's logic rationalized corporations' entitlement to export jobs to low-wage labor markets and validated the anti-public-sector rhetoric that shifted public spending from peaceful social goods like education and health to war, imprisonment, and corporate subsidy. With far fewer human beings employed as social connective tissue, we adjusted to the logic of automating human interaction. What else could we do?

To the degree this project succeeds, it makes us miserable. Machines have often been a boon to pleasure and freedom: if my home were on fire, I'm certain I'd save my computer, iPod, iPad, and iPhone before anything else. But I want to make use of them, not be controlled by them. If it were a pleasure to be treated like a cog in a machine, people would volunteer for it. Instead, those whose economic circumstances enable them to avoid interacting with public and private bureaucracies,

customer service departments, and the type of assessment that allows a number to stand for one's worth invariably employ a cushy buffer zone of specialists and factotums to insulate themselves from such diminishment. Everyone who can evade Datastan does. That doesn't stop them from prescribing it for the rest of us, though.

Thank goodness we so often refuse to cooperate! I feel deepest gratitude for the evergreen spirit that subverts any effort to reduce us to the size of our own creations. And how do we express our refusal to go along? In countless acts of insubordination, to be sure, but most often, and most clearly, colorfully, and energetically in the realms of art and culture. Art is the practice of freedom. Culture enlarges our spirits; connects us to our past, our future, and each other; and enables the imagination and empathy that support individual and collective resilience.

Are We There Yet?

To characterize this moment, I am often tempted to quote Karl Marx's language of 1848, which seems a perfect fit: "All that is solid melts into air," Marx wrote, "all that is holy is profaned, and man is at last compelled to face with sober senses, his real conditions of life, and his relations with his kind."[2]

Marx's lushly romantic language conveys the intoxicating mixture of confusion and hope we now breathe every day. But the anachronisms so evident in this passage speak volumes about how our collective response to radical social imbalances must be very different from his prescription. One hundred and sixty-four years later, ever-larger numbers no longer talk of man, but of humankind; indeed, we no longer think only of our own kind, but of the many interdependent forms life takes on this small planet. And few of us any longer believe that changes in the means and relations of production will alone suffice to fix the mess we have created.

2 Karl Marx, *The Communist Manifesto,* 1848

Yet we have something in common with Marx. He saw that in a period of seismic social movement, real and significant change is possible. So do I, and so do many social commentators. Those who fear such change advocate pulling our wagons into a circle, continuing to do what we have been doing all along—only more so. And those like myself, who hope to bring our actions in line with newly emerging possibilities, prescribe the opposite: an embrace of the opportunity revealed in this moment's hidden image, when ground and figure switch places.

Two factors suggest that it will be possible to make the shift in time, before the human project crumbles under its own weight. First is the growing number of people who recognize that the old order is not working for most of us. When I scan the field of mainstream social institutions, I see people who are willing to accept the questionable comfort of failing repeatedly in the same old ways rather than risk failing—or succeeding—in new ways. Even many of the people in charge of our systems of education, healthcare, justice, or defense are beginning to question their efficacy. So far, the commitment to the done thing— and the gentlemen's agreement that pretends to believe its claims, going along to get along—overrides these doubts. But you can only whistle in the dark for so long before seeking a candle.

Second is the rise of alternatives: the number of community-based organizations, green technology experiments, social entrepreneurs, and grassroots movements is remarkable. When Paul Hawken researched this phenomenon for his 2007 book *Blessed Unrest*, he estimated that worldwide, there are "over one—and maybe even two—million organizations working toward ecological sustainability and social justice."[3] With increasing popular activation in more world regions (as through the Arab Spring), the number has only grown since.

Change aggregates at the grassroots in individual lives and in communities for a long time before awareness rises high enough to

3 Paul Hawken, *Blessed Unrest,* The Penguin Group 2007, p.2

affect the official worldview expressed by political, business, and media leaders. What if the shift is already in process, but they just can't see it yet? What if the needed catalyst is a new lens that enables us to see what is already apparent if only we know how to look for it?

Changing The Lens

I often lead a workshop called "Refreshing Your Vision," guiding participants in regarding their work through unaccustomed lenses, offering a selection of perspectives. I ask each person to pick one that is markedly different from that individual's current orientation, something that requires a real stretch. Since most participants work with arts organizations or projects, the furthest reach tends to be sports. Imagine, I suggest, that your work is a form of sports activity: how would your experience change? Together, we walk through a half-dozen imagined situations—exploring the work space, considering who they'd work with and who would support their work, and so on—building up an alternative perspective on a familiar world.

The sports frame is enormously instructive. As people examine their work through that lens, rigid perspectives shatter and fall away. For instance, in the world of prestige arts organizations, there is often a vexed relationship between amateur and professional. "Sunday painters," "community theater"—these are often used as pejorative terms to describe people who have the temerity to practice an art form without blue-ribbon credentials, without self-conscious reference to the artworld's discourse and signifiers. We hear alarmed outcries about things like the erosion of standards, and a general sense that if you can't be bothered to pursue an art practice with the same expectations of preparation, the same standards and rigor that are perceived to characterize the red-carpet arts world, you shouldn't bother at all.

In contrast, although professional athletes undertake preparation and discipline every bit as demanding and rigorous as—say—concert musicians, they tend not to perceive amateur athletes as impinging on their work's value. In fact, kids' ball teams are felt to create an interest and cultivate participation in professional sports; watering the roots, so to speak. And the many ancillary sports activities—fantasy leagues, watching or listening to broadcasts, reading sports reportage, collecting cards or memorabilia—are understood to focus passionately positive attention on professional practice. To a remarkable degree, the prevailing view is that the entire landscape of amateur and professional sports works together as an ecology.

When people whose idea of their work has been constrained by establishment arts orthodoxies try to imagine themselves as sports leaders instead, a collective sigh resounds. They imagine their work as entailing a lot less *de haut en bas* and a lot more all of us are in this together. They imagine feeling far less need to justify themselves, let alone to see others as diluting or corrupting what they value. They imagine having more fun.

I'm asking you to see the world through the lens of a skilled and perceptive artist. Pay attention to where people are creating beauty and meaning in their lives and communities. Notice how often the form and content of art works are uniquely effective in expressing the spirit of the times, in articulating people's hopes and fears. See how it is possible to ignite understanding, to communicate across social barriers, to hold opposing views in the context of art, even in a time of highly polarized opinion. Consider how many people hold culture as a most prized possession, even how many are willing to live or die for it. Imagine a civil society consciously infused with the power of culture, consciously making use of art to create dialogue, invite social participation, build bridges across difference.

An Invitation to Dinner

Among the lenses I offer in the "Refreshing Your Vision" workshop, my personal favorite is entertaining guests. A teacher I respect once described her intention to me in exactly that way: "When I have people to dinner," she said, "I put out my best linen and dishes, I put flowers on the table, I cook the food I think they will enjoy, I play music I expect them to like. I welcome them in anticipation of the pleasure we will share. And that's how I want my classroom to be: my best offering, the best encounter, everyone leaving happy that they came."

It's a nice image, and—when workshop participants choose it as their focus—it also helps them break through a kind of impacted obliviousness that can develop after long years in a particular institutional role. I remember one arts-organization director exclaiming in horror as the contrast sank in: "I usher people into my office," she said. "It's a mess, stuff piled everywhere. I clear off any old space for them to perch. I act as busy as I feel. It's understood that we need to get our business done as quickly as possible so I can move on more important things. Sometimes, I've found myself wondering why people look so harried and apologetic in these meetings. But now I know: they're getting it from me."

The Culture of Possibility is my dinner-party invitation. I've been planning this meal for a long time: the book incorporates arguments, stories, and perspectives I have evolved from years of writing and speaking on the subject, as well as considerable new material. It consists of three sections: the one you are reading now, plus two different approaches to my subject, how seeing culture clearly can change despair to possibility. The thing is, I don't know your favorite dishes—your favored modes of receiving information, whether you engage best through stories, analysis, reportage, interaction, or imagination. So I've prepared a buffet. Each of the subsequent sections is different in approach. In terms of content, there's just a little overlap. They are intended to speak to different aspects of your sensibility. I hope you

will want to read both of them in any order you choose, and also the companion volume, *The Wave*, a fictionalized future in which the paradigm shift I am advocating has taken shape.

"Hidden in Plain Sight: Twenty-Eight Reasons to Pursue The Public Interest in Art," is just what it says: 28 short sections, each of which illuminates another aspect of the topic. Some are drawn from medicine, others from anthropology, commerce, spiritual practice, sociology, and many other spheres of knowledge. You can read them all or pick and choose. If you like the idea of bite-sized pieces, my advice is to start there.

"The World Is Upside Down" was written to describe the predicament we now face in the United States, in which the commercialization of absolutely everything is eroding even the idea of a commonwealth. As a symbol and illustration of the whole, it explores the way that art and artists have been treated in that context. If you are an artist, work with artists, or have any interest in public policy or private attitudes toward culture, this section may be your best entry into the material.

There's a mode of argument that entails heaping up quotations, the underlying idea being that if recognized experts support your views, they must be sound. I've certainly included quotations, illustrations, and examples throughout. But much, much more is available should you wish to explore the artists and others who are acting on the ideas that animate this volume. You will find starting-places and supplemental material—links, resources, action ideas—at my website, cultureofpossibility.net.

Special thanks to Sharon De La Peña Davenport, Adam Horowitz, and Tom Mandel for their help, to Martha Richards, Executive Director of WomenArts, and the Nathan Cummings Foundation for their generous support during the creation of this book, and to all the artists and activists whose work inspires me.

Hidden in Plain Sight:
Twenty-Eight Reasons to
Pursue The Public Interest in Art

1. To Expand Possibility, Face Both Past And Potential

The great writer James Baldwin said, "The purpose of art is to lay bare the questions which have been hidden by the answers." No one can know what the future will bring, but I am certain that possibility will expand if we face the questions that go to the heart, the root from which a culture commensurate with our challenges might sprout.

I ask these three all the time, everywhere I go. They appear in "The World Is Upside Down" as well, but because they are so central to my concerns, I want to begin by repeating them here.

Who are we as a people?

What do we stand for?

How do we want to be remembered?

Who are we? One set of responses may be deduced from behavior. Based on comparing how we spend our commonwealth in the U.S. to other countries, the answer to who we are is *Punisher*. We have the highest incarceration rates of any nation on earth, more than three times Mexico's, nearly five times the United Kingdom's, seven times that of France, 24 times that of India.[1]

At the end of March, 2012, Fareed Zakaria of CNN wrote a powerful "Incarceration nation" blog,[2] citing evangelist Pat Robertson (an unlikely

1 http://www.prisonstudies.org/info/worldbrief/wpb_stats.php?area=all&category=wb_poprate

2 http://globalpublicsquare.blogs.cnn.com/2012/03/30/zakaria-incarceration-nation-2/

bedfellow), whose recent endorsement of marijuana legalization was offered in recognition of the cost and failure of the war on drugs. Zakaria pointed out that

> The total number of Americans under correctional supervision (prison, parole, etc.) is 7.1 million, more than the entire state of Massachusetts. Adam Gopnik writes in *The New Yorker*, "Over all, there are now more people under 'correctional supervision' in America...than were in the Gulag Archipelago under Stalin at its height."...
>
> In the past two decades, the money that states spend on prisons has risen at six times the rate of spending on higher education. In 2011, California spent $9.6 billion on prisons, versus $5.7 billion on higher education. Since 1980, California has built one college campus; it's built 21 prisons. The state spends $8,667 per student per year. It spends about $50,000 per inmate per year.

Or judge by corporate welfare such as the late-2010 legislation extending Bush-era tax cuts (in which the U.S. Treasury lost $225 billion in revenues just from tax breaks specifically tailored to benefit high-income taxpayers). Then the answer is *Robin Hood in Reverse*. Or judge by war[3] and the associated profits (as of this writing, the U.S. has spent nearly $1.5 trillion on war just since 2001). Then the answer is *Bloodthirsty*.

What do we stand for? Countervailing answers emerge from even a glimpse of human potential. At every moment, the world overflows with stories that either support or depress social imagination and resilience. Try to list the violence, indifference, and damage meted out every day, and you will run out of hours before running out of items. Yet the beauty of the world proclaims itself perpetually: kind gestures between strangers, the soft silk of an infant's skin, the tender leaves of

3 http://costofwar.com/en/

early spring, red canyon rocks at sunset, two voices harmonizing on a familiar tune, a lover's touch, the scent of a ripe apricot, the lavender butterflies of an orchid in bloom. Acts of kindness and love outnumber destructive acts by several orders of magnitude. Even on a very bad day, at the very same instant that something terrible happens, what is good and sweet and right in this world is too profuse, too vast, too frequent to number, and much of it is the product of human creativity.

My personal spiritual practice is to hold desire without expectation. I want a lot: love, health, the experience of beauty, the ability to make meaning, community, planetary healing—it's a long list, I admit. The way I see it, to be alive is to desire. If I stop wanting to take the next breath, my life ends. If we subside into resignation, ceasing to allow ourselves to want whatever nourishes our collective well-being, we cede the territory of desire to people who are greedy for themselves alone, and community ends.

How do we want to be remembered? I am not a Pollyanna. I am not even an optimist. When it comes to the future of the human species, I am a hardcore agnostic. I know in my bones that human beings are capable of vast creativity, oceanic loving-kindness, and mind-blowing beauty. But I haven't the faintest idea if we are going to realize our potential. None of us can foretell the future, whether we try to accomplish that impossible task through divination or calculation. Just ask the people who abandoned their worldly goods to prepare for The Rapture in May of 2011; or the very smart and well-paid people who sat at computers betting their fortunes on the Ponzi scheme we now call the subprime mortgage meltdown.

So it's impossible to say with any certainty that if a large number of us expanded our vision, reframing our understanding of the public interest in culture, the epochal changes I describe in this book and in *The Wave* will unfold. But equally, no one can know that they wouldn't. There is only one thing I am absolutely sure of when it comes to the

future: people who don't get their hopes up will never see their hopes realized. Nothing can be created that has not first been imagined.

So, full disclosure: I am here to get your hopes up. In a demoralized time, it is so often not a stretch to obey the voice that says, "Don't dare to hope" and so very difficult to even take in the voice that says, in the words of Rebbe Nachman of Bratslov, "If you believe you can damage, believe you can fix." Facing the damage we've done, it becomes possible to discover the other answer to who we are: the people who can change that, the people with the will and imagination to live into that possibility, the people who can choose to spend their commonwealth on the constructive and creative.

2. The Time Is Ripe for Conscious Cultural Evolution

Culture is always a collective creation. It is animated by our desire to communicate and connect, to see and be seen, to know and be known. It exists wherever people have emerged from the isolation to which our spirits are prey and have entered into community. Culture is the crucible in which our individual and collective identities take shape, the container for our civil discourse, the medium in which families, communities, and institutions take root.

People commonly speak of the characteristics of a particular culture, whether defined by geography, shared heritage, or shared attributes and interests. One culture may be permeable and welcoming to strangers, another may be strongly bounded and insular. One culture may prize aggression or acquisition while another emphasizes sharing; one culture may understand families as structures of top-down authority while another sees them as the nucleus of community, as a site of negotiation rather than fiat. Such defining characteristics can be discerned in a culture's sacred texts, practices, or objects; its music, drama, and ritual; its iconography and aesthetic standards; its dances; its celebrations, commemorations, and heroes; the textures of daily life in its precincts.

Individual can choose to act counter to a cultural consensus. But whether one swims with the stream or against it, in significant ways, human lives are defined in relation to the source, culture.

It is easy to see this as a sort of natural process, like evolution or erosion: by increments too small to perceive, a culture aggregates, a syncretic mixture of influences emerging into coherence. But culture can also be the product of conscious choice, as when a people makes a deep transition—a paradigm shift—because their old model ceases to describe reality. This has been seen this many times in human history: the complete recreation of the Jewish people from a temple-based priesthood system rooted in space and sacrifice to a decentralized rabbinic tradition rooted in time and language, profoundly disrupting old patterns; or the nurturance of Tibetan culture in exile following that sovereign nation's takeover by the People's Republic of China.

A particularly illuminating story focuses on the Crow people, whose way of life was radically altered by white settlement and the destruction of hunting grounds. As the great Crow leader Plenty Coups put it: "When the buffalo went away the hearts of my people fell to the ground, and they could not lift them up again. After this nothing happened."

In the old Crow way, intertribal warfare and hunting were two chief realities shaping life. Status was gained by "counting coups," which in the case of the Crow people meant planting a ceremonial stake to mark captured territory. Jonathon Lear, the author of a wonderful book on this history, explained it this way: "Counting coups makes sense only in the context of a world of intertribal warfare; and once that world breaks down, nothing can count as counting coups."[4]

Lear explains that, facing no future, Plenty Coups went into the wilderness to seek revelation through a dream. His dream foretold the end of the Crow way of life, but it also promised new life if the people

4 Jonathon Lear, *Radical Hope: Ethics in the Face of Cultural Devastation*, Harvard University Press 2008

could learn to listen "like the Chickadee." This meant they had to observe others, and through their observations, find new ways of going on.

Perhaps the industrialized world today is not in the same position as the Crow people (although transposing oil for buffalo does suggest deep similarities). But for many reasons, life has radically altered in the face of circumstance: the old normal is no longer possible. Many of us are waiting for a new story that can console those who mourn the loss of the old one, and what's even more important, for a story that reveals new possibility, the credible hope of a livable future.

Part of the culture of Datastan[5] is a profound skepticism about change: the guardians of the old paradigm benefit hugely if most people are convinced that it is the only possible and the only enduring model, that there is no choice but to adapt. In counterpoint stands the communal reinvention of the Crow people and countless other examples of visionary leadership sustaining human history through the imagination of possibility in a time of constriction.

Today, at the intersection of paradigms, we have the opportunity to choose conscious cultural evolution, self-selecting our most powerful survival traits: awareness, empathy, creativity, our capacity for beauty, for meaning, for moral grandeur.

3. Our Own Stories Hold the Antidote to A Poisonous Political Culture

Not all works of art tell stories. But very often, our lives in art—the landmarks of beauty and meaning that line our paths through this

5 "Datastan" is the name I have chosen for the old paradigm shaped by a worldview that privileges whatever can be quantified and demands that we adapt to the terms set by our own creations, imposing machinelike linearity on social systems. The contrasting realm I call "The Republic of Stories," in which every story matters to the common good, in which everyone—and everything—has its story. In The Republic of Stories, nuance, particularity, imagination, and empathy are given their rightful places as capacities that enable essential knowledge about ourselves, the world, and our choices within it.

world—sprout from stories heard beginning in childhood. After all, the hunger for stories is intrinsic to human life. As soon as we are old enough to form the words, we beg for them: "Tell me a story, please!" As we grow, so does our hunger. Stories take more complex forms and come to serve more complicated purposes, but the through-line is constant: stories help human beings remember who we are.

The 18th-century wisdom stories of Rebbe Nachman of Bratslov still seem fresh today. Here is one I find particularly rich, the tale of the tainted grain:

A king once told his prime minister (who was also his good friend): "I see in the stars that everyone who eats from this year's grain harvest is going to go mad. What do you think we should do?"

The prime minister suggested they should put aside a stock of wholesome grain so they would not have to eat from the tainted grain.

"But it will be impossible to set aside enough good grain for everyone," the king objected. "And if we put away a stock for just the two of us, we will be the only ones who will be sane. Everyone else will be mad, and they will look at us and think that we are the mad ones.

"No. We too will have to eat from this year's grain. But we will both put a sign on our heads. I will look at your forehead and you will look at mine. And when we see the sign, at least we will remember that we are mad." [6]

To me, this parable is a straightforward account of our collective dilemma in the here and now. How do we remember who we are when our daily fare inculcates forgetting? It also poses a second question: is it enough to know we are mad, or are we obliged to seek the cure? In

6 From Rabbi Aryeh Kaplan, *Rabbi Nachman's Stories* (Breslov Research Institute, p. 481).

this fearful, frenzied time, it is easy to see ours as a society disconnected from our deepest truths, as if its citizens had consumed poisoned grain. Fanciful explanations abound. Consider one especially pure example: beginning with his first presidential campaign, Barack Obama's right to hold office was challenged by "birthers" who claimed that he was not a natural-born American citizen. In the spring of 2011, Mr. Obama released his birth certificate in an effort to discredit this smear. At the time, a *New York Times* survey[7] revealed that a quarter of Americans believed Mr. Obama was born outside the United States; a full 45 percent of Republicans held that belief. A year later, in the run-up to the 2012 presidential election, Donald Trump and Rush Limbaugh renewed the charge. Although neither was able to get much traction with mass media (news personalities dismissed the claims, sometimes with ridicule), polls in March 2012 showed that fewer than half of Republican voters in states such as Tennessee, Ohio, and Georgia believed the President was born here.[8]

People weren't getting all this exercised over a technical requirement of the electoral system. The meta-message was that Mr. Obama doesn't belong in the Oval Office because he is not "one of us." It doesn't take a genius to decode the racial anxiety and prejudice driving this feeling. But much of the controversy has been shaped by a tacit agreement to ignore what's really being engaged. Most media coverage reminds me of the denouement of *The Wizard of Oz*, when Dorothy and her companions are exhorted to "pay no attention to the man behind the curtain."

It's hard to find a better explanation for this form of derangement than contaminated grain, by which I mean a poisonous political culture fed by those who benefit from war, fear, and callous indifference.

7 Michael D. Shear, "With Document, Obama Seeks to End 'Birther' Issue," *New York Times*, April 27, 2011

8 http://www.publicpolicypolling.com/main/2012/03/limbaugh-and-birthers.html#more

Beth Grossman, a San Francisco Bay Area artist, has created many public conversations around the question of how things could be different if we lived by The Golden Rule, valuing others as ourselves. In 2010, she sat at one of her "table talks" in New York City with three men who worked on Wall Street. They shared some surprising confidences about their own very different backgrounds and their own feelings concerning the ethical challenges permeating the financial sector. As they talked, they made notes and sketches on the tablecloth, creating a visual record of the conversation. When it ended, Beth read all their notes. Here's what one man wrote: "I have to stop convincing myself that I'm doing this for my children." He did not write it on his forehead, but then, this reminder was addressed not to others but to himself.

The chief challenge facing those aligned with freedom, justice, and love in a society that denies these things their rightful value is to remember who we are. It is essential to pay attention to what we are consuming, to avoid inadvertently succumbing to tainted grain. That means discarding whatever says we are powerless or inconsequential in favor of whatever reminds us of our capacity for moral grandeur. It means remembering that none of us is immune to the prejudices and reactions that engender cruelty, to the pervasive temptations to place our own kind first, treating others as less than ourselves and using them as objects. It means being able to see the marks on own foreheads—and on others'—even when they are written in ink that seems invisible to so many of our fellow humans. These marks are signposts pointing to necessary change.

How is it possible to develop this discrimination? By engaging deeply with the question of who we are, rather than taking it as a given, as something assumed. In any form—theater, film, literature, visual art, song, dance, and more—depictions of our fellow human beings confronting existential questions invite us to empathize, to rehearse in the realm of imagination the challenges we may confront in real life,

to reflect on our own responses, and to interrogate and if necessary, revise them. Think about the deepest and most interesting conversations you've had with friends: I wager that at least half of them, often more, will have been inspired by the shared experience of a film, video, play, song, book, or other form of storytelling. So far, I haven't lost that bet.

Encountering the sublime in art also helps us to remember who we are: at once insignificant particles in a vast universe and the center of all being, the perceiver of all. When music moves us, we are invited to remember that we are the embodiment of beauty and pleasure, the listener among countless listeners, the receiver whose thoughts and feelings carried aloft on a melody connect us to others. When the familiar sights, sounds, and smells of a heritage celebration surround us, we are invited to recall that we are links in the great chain of being that sustains life; we remember our gratitude to ancestors and reconnect with our hopes for the future. When we experience new stories and ways of telling them that fall outside our prior experience, we are invited to remember that despite remarkable cultural diversity, we are all the same underneath, reacting in our different ways to the essential experiences of being human: life's beginning, love, fear, anger, delight, hope, despair, life's end.

These experiences are inoculations against the objectification doled out by the old paradigm which takes machines as models for human community, against the madness of self-forgetting it inculcates. It is possible to sleep-walk through a life, of course. But if I allow myself to enter in fully, art expands my self-awareness and awareness of others, cultivating agency and choice. And so it can be for anyone.

4. Art Illuminates Nuance, Yielding Deeper Truth

Datastan encourages the belief that truth inheres in the big story: a history book that offers details of battles, troop movements, proclamations, policies, and death tolls can make a reader believe he

or she understands a war, for example. But it's not until one's heart and head are fully engaged by the first-person stories behind those facts that real understanding can even be approached.

The reason this is so is expressed in a pair of phrases coined by the philosopher Isaiah Berlin. He called the big, obvious stuff of human events the "clear layer," because in scale and outline it is easy to perceive. The clear layer, he wrote in "The Sense of Reality,"[9] is "an upper, public, illuminated, easily noticed, clearly describable surface from which similarities are capable of being profitably abstracted and condensed into laws." Beneath it lies the much thicker "dark layer," which can be seen as a name for the aggregate of our individual stories. Berlin describes the dark layer as being made up of "less and less obvious yet more and more intimate and pervasive characteristics, too closely mixed with feelings and activities to be easily distinguishable from them...."

It's possible to generalize effortlessly based on the clear layer: that's how social and historical theories are propounded, and they keep on being propounded in hindsight even though they don't give us much foresight into future events, which are often astonishing.

But to really understand something, we must be willing to spend time in the dark layer with its multitude of little stories. Without these nuances—the subtle shades of meaning embedded in dreams, gestures, metaphors, and feelings—comprehension is so shallow, it cannot even be called understanding. A society that privileges the clear layer as much as today's United States risks a rude collision with reality: we spend tremendous resources modeling and predicting futures based on statistics and other quantifications of experience as if life were as orderly as a game. It is remarkable how little being repeatedly blindsided has shaken our faith in prediction: experts just call for better tools, as if they would enable us to foresee the next unprecedented cataclysm.

9 Isaiah Berlin, *The Sense of Reality: Studies in Ideas and their History*, Farrar, Straus and Giroux. (1996), p. 1-39

Consider what I am saying in terms of your own direct experience. Let's say you have a good friend, someone you've known, observed, and loved for years. Now bring a total stranger to mind, a trained and perceptive observer—a psychologist, say. Imagine that the psychologist could be given an abundance of clear-layer information about your friend: the circumstances of her birth, family, childhood, school transcripts, work record, all the "upper, public, illuminated, easily noticed, clearly describable surface." The stark truth is that no matter how much data were supplied to a trained professional, even when equipped with thousands of cold, hard facts, a psychologist could never foretell the behavior of your friend with greater accuracy than could a close associate with no special training at all. No doubt, the close associate would get it wrong a good deal of the time: people are unpredictable. But the stranger equipped only with clear-layer data would get it wrong far more often.

Multiply this by millions and you have a collective predicament. In Datastan the human heart can never be truly known, truly seen. Only in The Republic of Stories, the realm in which culture is given its due, can our stories be received with the attention that invites empathy and imagination, enabling revelation, understanding, healing action.

5. Art-making Is A Survival Trait

The philosopher Denis Dutton[10] argued that human artistic creativity is rooted in our development during the Pleistocene era. Ellen Dissanayake[11] has argued that art is an adaptive function in human evolution, because the arts are: "observable cross-culturally in members of all known societies;" "evident in our ancestral past...

10 Denis Dutton, *The Art Instinct: Beauty, Pleasure, and Human Evolution*, Oxford University Press.(2010)

11 Ellen Dissanayake, "The Arts After Darwin: Does Art Have An Origin And Adaptive Function?" in Zijlmans, K.. & van Damme, W., *World Art Studies: Exploring Concepts and Approaches*, Valiz. (2008).

from at least 100,000 years ago;" "their rudiments are detectable and easily fostered in the behavior of young children;" they "are generally attractants and sources of pleasure;" they "occur under appropriate and adaptive conditions or circumstances—that is, they are typically 'about' important life concerns;" and they "are costly: large amounts of time, physical and psychological effort, thought, and material resources are devoted to the arts as to other biologically-important activities…."

It turns out that these big brains that enable pleasure, make possible a remarkable and intense range of emotions, give rise to stupendous feats of imagination, use storytelling as a path to problem-solving, and allow us to create beauty in so many forms—our big brains are also a favored trait for sexual selection. When seeking mates, our earliest ancestors valued innovation, dexterity, grace, and other forms of skillfulness associated with art. Just as people wanted to mate with the best hunter or tracker, they wanted to mate with the best storyteller, the individual whose vivid depiction of events enabled everyone to learn something useful about avoiding danger, exploiting opportunity, and telling the two apart.

Surely this has something to say about the persistence and value of art-making in human history. The essence of being human is to make art. We do it in red-carpeted halls and ramshackle huts, at every moment of history, every time we mark the unfolding of our lives. Even under harrowing conditions, in SuperMax prisons and concentration camps, people save precious crumbs or scrape up clumps of mud to make sculptures. They scratch on prison walls with rocks or the burnt ends of matches. I was awestruck when I first learned that Herbert Zipper, the founding director of the National Guild of Community Schools of the Arts (now the National Guild for Community Arts Education), led a clandestine orchestra in Dachau. When human history began, our ancestors circled their fires, turning their backs on the darkness to share stories of the hunt, the trek, the storm and their meanings. Today

we sit in neat rows in darkened multiplexes, warming ourselves by the light of much busier and more complicated stories. But underneath, we are the same.

In the February 2010 issue of *Nature Reviews Genetics*,[12] evolutionary biologists wrote that "gene-culture co-evolution could be the dominant mode of human evolution." Their models show that cultural processes can have a profound effect on human evolution. In evolutionary biology, they talk about the concept of "niche construction" as a way to ameliorate the effect of physical forces on natural selection. Birds do it by building nests. The authors ask us to

> [I]magine an ancestral population that has been exposed to changes in temperatures. In the absence of niche construction, this would engender bouts of selection for genes favoured in hot or cold climates. However, if humans can put on or take off clothes, build fires, find caves and develop means of cooling, they effectively counteract these changed selection pressures. The temperature changes actually experienced by the population are dampened relative to the external environment and as a consequence selection is weak.

This is cultural in the largest anthropological sense in which clothing and shelter are understood as aspects of human culture. But rituals and customs have had the same impact: for instance, incest taboos have accelerated genetic predispositions not to mate with the people who raised us. And how are taboos and other social values transmitted in human community? Through legend, parable, ceremony, dance, and ritual—which is to say, through the methods of art.

My friend Dudley Cocke of Roadside Theater in Appalachia likes to say of human beings that "We are the storytelling animal, and language and story have been our selective advantage." Who can disagree?

12 Kevin N. Laland, John Odling-Smee, and Sean Myles, "How culture shaped the human genome: bringing genetics and the human sciences together," *Nature Reviews Genetics* 11, 137-148 (February 2010); http://www.nature.com/nrg/journal/v11/n2/abs/nrg2734.html

6. Art Enables Compassion,
Actualizing The Golden Rule

Our amazing brains and bodies subject us to ignoble impulses along with the creative and pleasurable ones. You may have heard of the behavioral studies conducted by social psychologists Stanley Milgram in the early 1960s and Philip Zimbardo in 1971. In Milgram's experiment, ordinary people were commanded by white-coated scientists to administer to experimental subjects electric shocks of up to 450 volts. In Zimbardo's Stanford Prison Experiment, students were arbitrarily divided into groups of inmates and guards, living together in a mock prison. The guards' abuse of prisoners escalated until the experiment was called to a halt after six days. But that didn't happen until Zimbardo's fiancée visited the site. Like almost everyone else involved, Zimbardo himself had become inured to the abuses; it was his visitor's appalled response that awakened him to the dangers.

When we hear about these experiments, most of us naturally grant ourselves an exception from the bestial behavior exhibited by participants. *I never would have gone along with that*, we think, wondering what was wrong with the people who did. But in Milgram's initial experiment, only one participant refused to administer 300-volt shocks, and 65 percent cooperated all the way to 450 volts. There are many ways to interpret these results, but almost everyone agrees that authority, peer pressure, and what might be called the normalization of sadistic behavior all played a part. In other words, no matter how evolved and compassionate we believe ourselves to be, there's an excellent chance that under the right circumstances, with the right companions, any of us is capable of terrible things.

This truth is encoded in the DNA of every spiritual and moral system recorded in the history of humankind. The universal antidote to cruelty is often called The Golden Rule. I like the way Rabbi Hillel put it a couple of thousand years ago: "Do not unto others that which

is hateful to yourself," although you can go further back to the biblical book of Leviticus for "Love your neighbor as yourself." Whether you find it corny or naïve or profound, the simple truth is this: if we were to treat ourselves and others with the same affection and care typically seen in people who value their own well-being, we would cease murdering each other, poisoning the air and water, objectifying those different from ourselves, and countless other commonplace behaviors that lead many people to despair of the future.

I have often proposed a one-line public policy grounded in The Golden Rule. As everyone knows, policy-makers sometimes prescribe measures for others they would find intolerable in their own lives, such as installing families in degraded or dangerous public housing, or consigning children to substandard and neglected schools. Consider what would happen if we required policy-makers and their families to live with the strictures they impose on others: if their families were required to attend public schools, live in public housing, use public health facilities.

If the sheer preposterousness of that makes you laugh, consider what your laughter means about the hegemony of our double standards. If we actually applied The Golden Rule, our seemingly intractable social problems would disappear like the witch in *The Wizard of Oz* who melted into a puddle of pure water.

The same grounding exists, then, for all moral choices: to know that none of us is immune from pressure, and therefore none of us can trust that we will always do good. The safeguard is to consider each challenge as if our own lives and our loved ones would be most directly affected by our responses.

Accepting that truth, how are we to keep ourselves in check? How do we guard against falling for our own propaganda, taking our own virtue as given, and thus making ourselves even more susceptible to error?

The key to a just and loving society is to cultivate awareness of our capacity for both harm and healing in every relationship. Indeed, every problem and opportunity we face is essentially one of relationship. Martin Buber expressed it best 90 years ago, when he contrasted two ways of relating to the world. An "I-it" relationship treats others as objects we can use; whereas "I-Thou" is a sacred relationship that holds infinite and equal potential for both parties, The Golden Rule taken to the ultimate power. To live by The Golden Rule requires that we develop the skills of imagination and empathy. We have to be able to imagine another's experience, and to see ourselves in the place of the other fully enough to feel genuine empathy. We have to hold dual consciousness, remaining self-aware and simultaneously aware of others.

We can't get there merely by thinking or talking about it. This learning has to be experienced in all dimensions: somatic, emotional, intellectual, and spiritual. And the strongest, clearest, most powerful place in our world where all of these dimensions converge is in what we call art.

Imagine yourself listening fully to music that you love. Your body is engaged, not only because we experience music through the movement of tiny body parts in our ears, which is then translated into nerve impulses our brains can perceive. Music's rhythm, tempo, and volume precipitate sympathetic vibrations in our bodies; the imagery and mood evoked by music trigger brain chemicals that in turn excite physical sensations. If these are potent enough, the impulse to move is irresistible. We are flooded with emotion. Images and ideas flow through our awareness, moving in time to the music. When the music holds great meaning, beauty, or power for us, we experience it as sublime, inexpressible. The same possibilities for engagement are latent in every art form.

This integral state of simultaneous somatic, emotional, intellectual, and spiritual engagement with art can kindle the desire for knowledge

and wisdom, for an embrace of our full human capacity. When art's intention is I-Thou relationship, it can teach us to actualize The Golden Rule.

7. Art Develops The Latent Human Capacity for Empathy

Scientists have detected the presence of an "empathy gene," a receptor gene for the hormone oxytocin, which promotes social interaction and the formation of bonds of friendship and love. Neuroscientists have also have found "mirror neurons" in the human brain. It is uncertain whether these are specialized neurons or an inherent cortical capacity. But when human beings observe someone else (or imagine ourselves) experiencing a feeling or performing an action, nerve impulses are activated very much as if we had performed the same actions with our own bodies. Mirror neurons are thought essential to empathy, enabling understanding of other people's perceptions, actions, and feelings. They enhance the capacity to learn through imitation.

So the ability to feel empathy is encoded in our physical beings. But imaginative empathy does not automatically infuse anyone's life-choices, any more than possessing the physical equipment for dancing or singing means you or I will actually do either. Moving from the latent capacity to the practice of compassion must be learned. When I sit in a darkened theater, opening my mind and heart to stories very different from my own, the tears, laughter, or perplexity I feel activates these capacities, setting that learning in motion. The more opportunity I have to experience empathy with characters different from myself, the more my potential for understanding and compassion is enlarged.

Scientists are beginning to study and understand this. As a result, brain development researchers like Antonio and Hanna Damasio of the Brain and Creativity Institute at the University of Southern California have become advocates for arts education, pointing to art's value in

generating a moral sense. Rapid and intense changes in the way we spend our time, the way we communicate and process information, have created "a growing disconnect between cognitive processing and emotional processing...," they write.

It has been classically claimed that cognition and emotion are two entirely different processes for the human mind and for the human brain. And that, somehow, a rational mind would be one in which cognitive skills developed to a maximum and emotional processing would be suppressed to a maximum because somehow, emotion would not be a good counselor of cognitive creativity. We have to tell you that not only do we not agree with this claim but that everything that has occurred over the past ten years of cognitive neuroscience reveals that this traditional split is entirely unjustified.

[A] curriculum which features arts and humanities education is one way of conducting the moral exercises on which citizenship is grounded... Arts and humanities education can be a playground for the development of good citizens.[13]

To me, the best argument for arts education is that children today practice endlessly interacting with machines, developing a certain type of cognitive facility. But without the opportunity that deeply participatory arts education can afford—to face human stories in all their diversity and particularity, to experience emotional reactions in a safe space and rehearse our responses, to feel compassion and to imagine alternatives to systems that aren't working—their emotional and moral development will never keep pace.

This does not apply only to the ever-fewer courses sequestered into formal arts education. Think of yourself as a learner. How do you want to be taught? From that perspective, the best education is lovingly

13 From Dr. Antonio Damasio's speech at the World Conference on Arts Education, sponsored by UNESCO in 2006, available at http://portal.unesco.org/culture/en/files/33947/11798495493AntonioDamasio-SpeechRevised.pdf/AntonioDamasio-SpeechRevised.pdf

tailored to cultivate each student's unique capacities. This requires relationship: the time and effort for caring adults to get to know a child as an individual; the pleasure that inculcates a love of learning sufficient to support lifelong curiosity and self-development, an open heart and mind. We know that children cannot be made to learn; their resistance to force-feeding, whether nourishment or knowledge, will defeat the attempt.

One proof of this is the fact that in droves, parents with sufficient means (and others willing to shoulder the necessary debt) are eschewing public schools shaped by standardized testing and automated teaching methods in favor of private schools with better student-teacher ratios and curricula that cultivate the whole person.

For the rest of the nation's children, U.S. education policy seems to have been crafted in Datastan, that flatland nightmare of an old paradigm that worships hyper-efficiency, hyper-rationality, hyper-materialism and domination. In Datastan, deep knowing is devalued in favor of a fascination with numbers that amounts to brain-damage. Datastan is the No Child Left Behind Act, where the phrase "scientifically based research" appeared 111 times, premised on the idea that the quality of education can be measured best by control-group research that yields quantifiable data, as if children were widgets.

With public education shaped by this emphasis, there have been massive cuts in arts courses and programs, but very little discussion of the human price these will exact. What sort of citizens will students become who have not been given the encouragement and opportunity to develop their own sensibilities and explore their own feelings and perceptions through artistic creation and interaction?

The remarkable "Teaching for Understanding" initiative of Project Zero at Harvard's Graduate School of Education suggests an answer, that the result may be knowledge without understanding. In the TfU framework:

If a student "understands" a topic, she can not only reproduce knowledge, but also use it in unscripted ways. For example, a student in a history class might be able to describe the gist of the Declaration of Independence in her own words; role-play King George as he reacts to different parts of it; or write out parts of an imagined debate among the authors as they hammer out the statement. These are called "performances of understanding" because they give students the opportunity to demonstrate that they understand information, can expand upon it, and apply it in new ways.[14]

Obviously, they are also called "performances" because that is exactly what they are: retelling, role-playing, and scripting an imagined moment are key steps in the creation of drama. The skills of imagination, improvisation, and communication they entail are learned best as art practices, where work and play are joined. In standardized tests, students may parrot back memorized information, but to demonstrate deep understanding, including imaginative empathy, they must deploy the means of art.

Nearly every study mirrors the conclusions reached by The Partnership for 21st Century Skills that "Students' capacity to create and express themselves through the arts is one of the central qualities that make them human, as well as a basis for success in the 21st century."[15] The Partnership highlights a slew of strengths that can best be taught through arts education, including critical thinking and problem solving, communication, collaboration, creativity, innovation, flexibility and adaptability, initiative and self-direction, social and cross-cultural skills, leadership, responsibility, and many more.

Beyond these specific capabilities, there is a profound truth of our changing world: students today are preparing for jobs and social roles

14 http://www.old-pz.gse.harvard.edu/Research/TfU.htm
15 http://www.p21.org/documents/P21_arts_map_final.pdf

that haven't even been imagined yet. They cannot be trained in the narrow sense for jobs that do not yet exist, but they can learn essential creative skills and capacities, and that learning can equip them to respond to emerging challenges and opportunities, whatever they may be.

Knowing this, it is even more horrifying that the decline of arts education has been felt most severely in communities of color. A 2011 National Endowment for The Arts (NEA) study reports that:

> [T]he decline in the rate of childhood arts education among white children is relatively insignificant from 1982 to 2008, just five percent, while the declines in the rate among African American and Hispanic children are quite substantial — 49 percent for African American and 40 percent for Hispanic children. These statistics support the conclusion that almost the entire decline in childhood arts education between the 1982 and 2008 SPPAs was absorbed by African American and Hispanic children. [16]

Students deprived of arts instruction and creative experience in school can still learn and develop their own creativity, of course. Their lives are full of stories, but for most, the bulk will be stories created by others with a commercial aim in mind: to sell the next version of "Call of Duty," to attract sponsors to "Family Guy." These stories do not exist to unearth buried history, to enable understanding across barriers of difference, to teach The Golden Rule or other moral lessons grounded in empathy, nor to nurture curiosity and a desire for deeper knowledge of the human subject. I have an abiding faith in human resilience, in our capacity to thrive despite a dearth of support or confirmation. But when we reject abundant evidence of the critical role of creative engagement in individual and collective development—when we act as if such things are frivolous and expendable—the hubris of our faith in Datastan threatens to overwhelm us, and I feel fear.

16 Nick Rabkin and E. C. Hedberg, *Arts education in America: What the declines mean for arts participation,* National Endowment for the Arts, February, 2011.

Who are we as a people? What do we stand for? How do we want to be remembered? An educational system that answers these questions will teach resilience, imagination, improvisation, empathy, and critical thinking, infusing the entire curriculum with the artistic methods and approaches that enable vivid, embodied, first-person learning and understanding.

8. *Art Cultivates Capacities Essential to Excellence in Many Professions*

The ability to craft or perform a compelling narrative is part of professional training in many spheres: in sales, for instance, or the law, it is a core competency. But the professional value of artistic methods extends beyond storytelling. In an experiment at Yale Medical School, half the students took an introductory art history seminar, and that translated into significant improvement in their diagnostic skills. Nancy Adler, a painter and S. Bronfman Chair in Management at McGill University in Montreal, wrote that this is

> Because learning to see art teaches people to see both the details and the patterns among details….Rather than simply making global assessments based on what they had expected to see, the art-trained medical students more accurately saw the actual condition of the patients. After only one year, the art-trained student doctors' improvement in their diagnostic skills was more than 25 percent greater than that of their non-art trained colleagues. Based on the success of the experiment at Yale, more than 20 additional medical schools have added art history to their curriculum. [17]

A rapidly growing literature documents art-based learning as a way to cultivate professional capacity in many fields. Typically, participants

17 Nancy J. Adler, "Leading Beautifully: The Creative Economy and Beyond," *Journal of Management Inquiry* 2011 20: 208. http://jmi.sagepub.com/content/20/3/208

in these experiments have previously experienced the narrowly focused intensive style of training conventional in their professional spheres, designed to build confidence in a body of skills grounded in relevant information and practical experience. Such training privileges hard data and intellect—skills of memory and analysis, for example—but downplays the useful information that can be acquired through noticing one's physical sensations or emotional responses to an object or situation.

While conventional training modes may make for competent doctors and lawyers, competence is necessary but not sufficient to true excellence. And it has a significant downside: for instance, absorbing a vast body of common knowledge frequently leads to confirmation bias, privileging information that confirms an existing hypothesis. As Nancy Adler's comments imply, the default temptation is to quickly sort what one perceives into a pre-determined diagnostic category, then to search for supporting evidence. Being trained to see without preconception— to perceive the actual condition or situation—leads to fewer mistakes, whether one is diagnosing a medical condition, a legal case, a marketing problem, or a social issue.

What if in every profession, education drew on the skills and habits of mind and heart characteristic of artists, employing artists to teach? What professional practice would not be improved if practitioners learned to see without preconception, to improvise, to perceive patterns, and to generate new ideas and relationships? In The Republic of Stories, the value added by art is understood, and the time and money needed to derive it are seen as well-spent.

9. The Story Field Is A
Reservoir of Wisdom and Guidance

Datastan undervalues our capacity to generate beauty and meaning, treating stories almost as mother's milk was treated during the scientism-enraptured 1950s—at best of vestigial utility, easily replaced by superior

manufactured products. Now, of course, scientists know that breast milk conveys many benefits, including immunity to or decreased risk from a wide range of illnesses and deficiencies. Just so, the human proclivity to create shapely retellings and depictions of interesting or instructive happenings and imaginings has been critical to our species' ability to learn from experience, extracting needed wisdom from events that otherwise seem random. But without eyes and ears open to perceiving this value, it will not be apparent.

Consider how many stories have been written, chanted, whispered, drawn, danced, projected, and imagined since humans appeared on this planet. If each story were a butterfly, the earth would be carpeted in brilliant iridescence. If each story were a particle or wave of energy, the planet would be encased in a story field, a web or matrix of tales that binds and sustains our collective existence.

Can you see the planet spinning and glittering in your mind's eye? Take a moment to explore it in your imagination. Bring to mind a time when someone taught you a song, read you a poem, pointed to an obscure corner of some complicated image, drawing your attention to a detail that had previously escaped notice, or showed you a dance step that filled your body with delight. Concentrate on that moment. Try to remember the sights, sounds, and scents of that moment. Try to remember how it felt to receive and discover.

Now focus on the face of your benefactor, the infectious delight, the caring and generosity that attach to the gift of culture. And when you have that image in mind, pull back and imagine the person who gave it to the one who taught you. And the person who gave it to your benefactor's teacher, and to that teacher's teacher, as far into the past as you can conceive.

Each of those individuals occupies a single point—a single particle or wave of energy—in the story field. And so do you.

Now hold that image and at the same time, move your attention in the other direction. With whom will you share the teaching you received

from your benefactor? Perhaps you've already taught someone else the song or read aloud the poem or screened the film for your beneficiary in this great cycle of cultural transmission. Perhaps you want to imagine a future moment when you will first tell a story or sing a song and watch your friend's face light up. When you have the moment in mind, picture your student teaching this same thing to someone else, and that person teaching it to someone else, as far into the future as you can imagine.

What you see in your mind's eye is vast, yet it is only a glimpse of a single corner of the story field, a network of human creativity emanating from each and every person who has ever lived—or will ever live—on this planet.

"Holy! Holy! Holy!" wrote Allen Ginsberg, "The typewriter is holy the poem is holy the voice is holy the hearers are holy the ecstasy is holy!"[18] The story field is holy. Art is sacred play, as nourishing to us as mother's milk to an infant. I find it astounding that humankind has amassed this vast reservoir of stories, weaving the ties that bind all cultures since the beginning of time, yet so many of us have succumbed to the hubris of Datastan, a realm in which all this is reduced to icing on a flat and tasteless data cake. The story field is ours to reclaim.

10. All Stories Matter: In Their Giving and Receiving, The Possibility of Healing Is Born

We are all living in the midst of the story field, but a single mind cannot comprehend it fully: it is just too vast, too far beyond our human ken. So it is human to search for meta-stories, the grand narratives that transcend the clutter and incident of our lives, that seem to make it all fall into place by helping us to see that we are part of something much larger.

That's a good thing, the human desire to make sense. But it carries a risk, rendering us susceptible to those peddling readymade narratives.

18 Allen Ginsberg, "Footnote to Howl" in *Howl and Other Poems*, City Lights Books (1956)

History is packed with tales of one group attaching to a story that aggrandizes its own position at others' expense. The "white man's burden" was one such narrative, equating pale skin with superiority and that status with an obligation to "civilize" everyone else by destroying their institutions, suppressing their spiritual practices, and if all else failed, taking their lives. Change the label and you've got the "Rape of Nanking," the massacre of Chinese people by Japanese troops in World War II; or the Hutu-Tutsi conflict in Rwanda, Burundi, and Zaire, and others too heartbreakingly common to number.

Those who hold power attempt to impose a dominant narrative that keeps them there. They almost always start with history, positioning the present as the inevitable result of a specific version of the past, as the destiny that confers their rightful place and power.

You've heard of "the Great Man Theory of history," no doubt. In this framework, history is made by individuals of extraordinary ability and power who shape the course of events through force of personality. In this framework, Lincoln freed the slaves, while the generations who labored so long and hard to escape, subvert, and oppose slavery were merely his supporting cast. In this framework, all that is worthy and good in our heritage derives from possessors of wealth and privilege, leading to the conclusion that the words and images and costumes and furniture and decorations of such people should be preserved and exhibited for the edification of future generations. In the Great Man model, a society has one true culture, and everything else is dubbed subculture or folk culture and considered second-rate. Everyone has a role, but mostly as members of the audience.

The story revolution, the one that is transforming the world, is fueled by a democratic counter-assertion: that everyone contributes to culture, that the knowledge sorely needed by future generations must come from every ethnic group and region and social class, from human beings of infinite variety, and that everyone has something to teach and something to learn.

It makes common sense that everyone ought to be cherished equally as a member of the human community: The Golden Rule writ large. By now, the obverse seems deeply crazy: can we really expect the problems of our world to be effectively addressed while most of humanity is viewed by those in power as raw material for industry or market segments, nuisances or cannon-fodder? I have discussed these ideas with many people, and most have instantly grasped the essential truths of The Republic of Stories, which seem to be self-evident: that their own stories and the stories of their communities do matter, that such stories need to be told and heard, and that in their giving and receiving, the possibility of healing is born.

This idea is already out and about, a billion butterflies already unleashed into the atmosphere. It explains why, even in the clear layer where public information resides, some things have begun to change. Museums can't get away anymore with exhibiting only the art of white men or solely the artifacts of the wealthy. Public television broadcasts programs about civil rights movements, Latino histories, Asian cultures, and women's contributions to many fields. In progressive education, the late Brazilian educator Paulo Freire has had a tremendous influence with his observation that the key to liberating education is to learn to speak one's own words in one's own voice. The market for what is called "world music" is burgeoning; even multiplexes sometimes show independent films; first-person memoirs and oral histories fill bookstore shelves; and countless theaters open their stages to the new stories emerging into visibility in their communities.

This through-line can be discerned beneath the surface of so many of our public troubles: on one side, entrenched power says, "I speak for everyone, I think for everyone, what benefits me is good for everyone." On the other side, thousands upon thousands of people say, as Freire has put it, that they are subjects in history, and not its passive objects. They create culture. They have the right to think for themselves, to tell their

stories for themselves, and to be received with the same expectation of dignity and respect that people in power accord themselves.

Progress isn't steady: Datastan puts it foot down, and The Republic of Stories must press forward regardless, a path of two steps forward, one step back. But a path, one that more and more people are taking.

11. More and More, Our Desire Path Is The Path of Art

In 1958, the French philosopher Gaston Bachelard coined the phrase "desire path" to describe the pathways that people naturally make by walking from one place to the other as opposed to the roadways that have been made by planners and engineers. You can see these most easily in the snow: in the absence of predetermined trails, people's feet track the evidence of their desire, sometimes taking the most direct shortcut between two points, sometimes meandering past an especially beautiful prospect or a beloved natural feature. When the snow melts, a gap becomes evident between planning and the wishes of the human heart.

The hubris of modern times has been to imagine that the looping meanders and rough edges of our desire can be supplanted by the imposition of an artificial order that seems, in the Olympian space of the conference room or laboratory, ever so much neater and more efficient. The smartest planners are learning now, half a century after Bachelard coined his term, that an organic approach is far superior, taking time and investing attention to allow the lines of desire to emerge before the paths are laid.

As usual, when new truths surface in other disciplines, they have almost always been articulated first by artists. Half a century before Bachelard, in his most famous work, the Spanish poet Antonio Machado wrote lines that carry the same deep wisdom. In English and the original Spanish, they are:

Traveler, your footsteps
are the road, nothing more;

traveler, there is no road,
you make the road by walking.

Caminante, son tus huellas
el camino, y nada más;
caminante, no hay camino,
se hace camino al andar. [19]

Despite vast pressure to persuade us to walk a social path in which punishment or profit or machinelike efficiency are our collective priorities, in actuality, our desire path, the road we have made as individuals and communities, is the path of art. All around us, people are living out this truth. Every day, in every corner of this country, nearly every life, nearly every waking hour, is saturated with music, stories, visual imagery, and conscious movement expressing the intrinsic nature and overwhelming resilience of human creativity.

The cumulative result of millennia of creativity embodied in art-making is a repository of wisdom, social imagination, empathy, beauty, and meaning that is essential to surviving the crises our society now faces. It sustains us through difficulty and inspires us to make change. It provides the container, the matrix, for all human knowledge.

12. How We Shape Our Stories Shapes Our Lives

The most intimate road any of us makes is the desire path through our own experience, our inner map of life. As we live, our lives are just a string of incidents: I was born here, then I moved there. I liked strained carrots, but now it's pizza. I played with Barbie dolls or Tonka trucks, I had the measles, I had a birthday, I got a job, I lost a job, I fell in love and then fell out again. Life is merely one thing after another until we create the narrative that gives it meaning. We can't have true sight or

19 "Proverbios y cantares XXIX" [Proverbs and Songs 29], *Campos de Castilla* (1912); trans. Betty Jean Craige in *Selected Poems of Antonio Machado* (Louisiana State University Press, 1979)

draw true understanding until we give our experiences coherent form. The way we shape our stories shapes our lives.

Every one of us has seen it countless times: two individuals describe nearly identical experiences in radically different terms, giving them opposite meanings. Even in the most extreme circumstances, this is true. One individual living with a dire cancer diagnosis reports that despite terrible suffering, it refocused her attention on life, motivating her to embrace her most meaningful relationships and pursuits and to drop whatever was superficial or distracting. Another with the same diagnosis cannot stop protesting at the unfairness of fate that a good person such as herself must suffer so. She subsides into resignation and despair. Events invite either view, but one story makes the remainder of life bearable, and the other makes it an unrelenting punishment.

Even ordinary actions and experiences can take on completely different meanings, depending on how we name them, on how we shape the story. Imagine yourself standing at a kitchen counter, chopping vegetables for dinner.

First, imagine that the meal you are creating is for a person you adore. As you chop, you anticipate the delight you will feel when your food makes that person smile and say, "Delicious!"

Nice image, hm?

Now imagine that you're on KP duty in the dining hall of a state penitentiary, and the food is going to be tasteless, hastily consumed, and probably not much different from the last meal or the next for a dozen years to come.

Same actions, different story, not so nice.

Yet many people choose to put themselves in situations very like the latter and find a way to feel as if they were experiencing the former. If you worked as a vegetable-chopper in a refugee camp or field hospital, and as you chopped, you saw yourself extending love in the form of food to people whose lives might be lifted out of misery by that small

gesture, then you might not be daunted by the mud and blood and chaos surrounding you. Your story would support your work, lifting it into higher meaning, allowing the challenges to recede. It would enable you to distinguish figure from ground, choosing your own perspective.

As I write, I am conscious of curating my own story. I can see myself as the harbinger of a new paradigm—a new understanding of art's purpose and meaning—or as the advocate of an extreme view that can never compete with the dominant perspective. I choose the former.

If you are an artist, you can see yourself as someone skilled at making images or words, or at using the voice or body or enabling others to experience those skills, and who hopes to be noticed and rewarded for it. This is a necessary truth, but not sufficient to hold the full meaning of your experience. You can also see yourself as someone who is always in the process of becoming an instrument of beauty and meaning, who is always learning to show up in an integrated state, fully present and engaged in all dimensions, and who therefore has a very special role to play in the world.

If you are a doctor, you can see yourself as a repository of knowledge about the body and its ailments—also true, but incomplete unless you also understand yourself as someone who knows how to align him or herself with another's recovery, which entails both external intervention and the deeply private intervention whereby a patient mobilizes healing will and intention.

If you are a teacher, you can see yourself as a responsible adult, charged with keeping order and meeting lesson plans and test-score targets. Or you can see yourself as the steward of young lives, able to help students understand and develop their own gifts, to experience the pleasure of life, and to inhabit full cultural citizenship.

There is almost always a larger, more enabling story, and almost always, that story at least alludes to archetypes and resonant characters from creative work. For example, only two words are needed—

Moses and Mandela—to speak volumes about the one who leads his people from slavery; the leader who identifies with Moses has the Promised Land in sight, rather than seeing himself as a small figure battling far greater forces. A world of intention and motivation lives in the distinction. Being aware of choice, knowing what choices are possible, choosing for enhanced capacity and impact—each of these capabilities essential to shaping conscious and empowering stories is cultivated best by the experience of art. Supporting our capacities as storytellers and listeners will help shape the collective stories that elicit full human potential.

13. Reframe The Public Interest in Art to Cultivate Awareness and Empathy

In cognitive linguistics, a "frame" is one of the conceptual schemes that organize our thinking, coloring the meaning of words, images, and other information. Frames are embedded concepts—constructed of words and images, metaphors and parables—that shape our perception and therefore our opinions. The meanings of facts change depending on the frame. Indeed, the same piece of information can be positioned as essential or irrelevant, foreground or background.

In the political arena, most frames incorporate moral appeals. The debate over reproductive choice, for instance, evokes two principles many people hold sacred: personal self-determination and the sanctity of life. Embedded in each frame is the implication that adopting that position makes you a good person, while the opposite opinion is morally questionable.

Charlotte Ryan and William Gamson have written a great deal about the use of framing in influencing public opinion. "A frame is a thought organizer," they write. "Like a picture frame, it puts a rim around some part of the world, highlighting certain events and facts as important and rendering others invisible. Like a building frame, it holds things

together but is covered by insulation and walls. It provides coherence to an array of symbols, images, and arguments, linking them through an underlying organizing idea that suggests what is essential—what consequences and values are at stake. We do not see the frame directly, but infer its presence by its characteristic expressions and language."[20]

"Reframing" means changing the frame around a subject or viewpoint, annexing new meanings to alter people's relationship to an idea. I wrote this book to reframe the public interest in art and culture.

Some people are annoyed when voters respond to political campaigns that substitute emotive imagery for the facts and figures they believe ought to undergird logical conclusions. It feels like manipulation, and that feels fishy. But peel back those layers of judgment for a moment and consider this: what if human brains really are wired to respond more powerfully to stories, images, and feelings than to data? What about you? What affects you more deeply, a thick white paper full of bar charts and policy-speak, or a powerful story about the human impact of policy? Even if you share my own wonkishness and like to curl up with a white paper now and then, you will observe that the facts and figures you devour derive their force from stories and images you have elsewhere taken in. Learning the number of gallons of oil that escaped into the Gulf after the BP oil spill horrified us because it scales up the damage we saw and heard on television or the internet. Having seen an image of a bird drowning in oil, we mentally multiply it by thousands.

Reframing is not a process of making a logical argument, nor of trying to talk people out of the old meanings they attach to a subject or issue. It engages the senses, employing imagery, association, visual and tactile information along with ideas. We assign value and make decisions based on what cognitive linguist George Lakoff calls "real reason," which incorporates our bodies, emotions and spirits as well

20 William A. Gamson and Charlotte Ryan, "Thinking about Elephants: Toward a Dialogue with George Lakoff," *The Public Eye Magazine*, Fall 2005

as our intellects. People make decisions about the important things in life, including politics, through story, metaphor, physical sensation, and emotion, as well as through logical calculation.

New Yorkers who opposed an Arabic-language public school called themselves the "Stop The Madrassa Coalition." The Texas Board of Education voted to replace the word "capitalism" in textbooks with "free-enterprise system." But it's not all words. Tea Partiers used costumes, props and other imagery identified with the American Revolution to associate their movement with freedom from tyranny. Successful reframing resonates with deeply held values and stories: the Tea Partiers plugged into a readymade storehouse of Founding Fathers images that gave them a headstart in going viral. With somewhat less success—perhaps because, Arabs having been vilified so insistently and successfully, the embedded images they evoked were not purely positive—the Occupy movement plugged into images of irrepressible democratic freedom annexed from Arab Spring.

When a powerful frame is put around issues, it can be difficult to dislodge, no matter how distorted it makes the picture. For example, have you heard of an "availability cascade"? First, an idea or belief catches on quickly; most often, it is a simple explanation for a complex phenomenon. Pretty soon everyone in your network is talking about it, and without engaging your critical intelligence—without examining the idea to see if it holds water—you find yourself buying it too. The feeling is that you just have to accept it or risk being seen as out of step.

For instance, we have swallowed the idea that economic conditions sadly require elected officials to slash spending, and we all must share the pain. Everyone knows it, therefore it must be so. Most advocacy campaigns for the arts, social services, education, and so on are conditioned on the shared belief that the best we can do is hold steady.

How does that fit with the facts? In reality, for more than a decade, we taxpayers have been spending more than two annual National

Endowment for the Arts budgets a day, seven days a week, on war. I've already mentioned the legislation extending Bush-era tax cuts that lost the U.S. Treasury $225 billion just from tax breaks created to benefit high-income taxpayers. In 2010, corporate profits grew by 32 percent, while overall economic growth was 4.2 percent. In 2011, growth in profits was slower, with an overall increase of only 8 percent, but in dollars, it has been sky-high straight through the recession: fourth-quarter 2011 profits totaled $1.58 trillion, 36 percent above their prerecession peak of $1.16 trillion.[21] Analysts say that a significant portion of those profits comes either from continued job cuts or corporate decisions not to rehire as profits rise: these days, rather than creating jobs or investing in infrastructure, the prime directive for many businesses is to pump up shareholder profits and executive compensation at everyone else's expense.

In other words, despite the availability cascade that convinces many to think otherwise, economic suffering is not distributed evenly, everyone is not being cut proportionately, and the pain of cuts is not being shared. Instead, things like culture and education bear a disproportionate burden by absorbing the share that would have been borne by war, prison, corporations, and the wealthy.

Have you heard this joke? A oil company CEO, a Tea Party member, and artist are sharing a plate of a dozen cookies. The CEO helps himself first, taking 11 of the 12 cookies. Then he turns to the Tea Partier and says, "Watch out! That artist wants a piece of your cookie."

The CEO is applying the same frame that has constrained advocacy in a time of pervasive belief in "shared pain" despite a reality of unevenly distributed suffering, far less at the top than at the bottom of the economic ladder.

21 U.S. Department of Commerce Bureau of Economic Analysis news release, 29 March 2012: http://www.bea.gov/newsreleases/national/gdp/2012/gdp4q11_3rd.htm

One of the best exercises to help people frame issues uses two different images of the same scene. In the first image, cows are lying in a meadow on the verge of death. Focus group members say the cows are sick because the farmer didn't feed or water them. In the second image, the frame pulls back to reveal a factory belching black smoke. The focus group builds a very different list: the water has been poisoned by runoff, the air by toxic fumes, and so on.

The frame has already been pulled back on our ailing public investment in culture and other social goods. I hate to see citizens sitting blithely by while politicians fund the planet's largest prison system, subsidies for Big Oil, a war industry that beggars imagination, and tax breaks for the wealthiest, then pretend to believe that we can't afford decent education, healthcare, or the kind of cultural development investment that even the poorest nations typically make. The surrealism of that big lie and the evident ease with which so many people swallow it indicate a cultural crisis of epic proportions.

Once again, the antidote is awareness, and awareness is grounded in empathy and imagination, the essence of art. The public interest in art includes its ability to cultivate awareness and compassion.

14. To Balance Anti-Public Interest Forces, Deploy The Political Power of Metaphor

For decades now, the U.S. right has been depicting the public sector as an enemy of freedom and a failing business: in short, an inept Big Brother. In this frame, government wastes money, rewards corruption, exploits taxpayers, stifles enterprise, and forces bad products down our throats. And the private sector is held aloft as government's opposite: accountable, forward-thinking, efficient, and responsive.

Why is this frame so sticky, so persistent and evidently convincing? There's some truth in it, of course: it's not that government is a model of competence and efficiency. We've all heard the horror stories: paying

defense contractors hundreds of dollars for a tool that would cost $1.99 at the local hardware store, officials' junkets at public expense, and government programs that do more harm than good. But anti-government feeling has begun to obscure the simple truth that the marketplace cannot be relied on to support the public goods required to sustain any society. Should access to clean water be reserved for the highest bidder? Should we accept that children whose families lack capital sufficient to pay private-school fees do without school? Should protected public lands be sold off to resource-extractors and developers? Should health and safety regulations that keep toxic chemicals out of children's toys be repealed? Should it not trouble us that the indigent die from lack of medical care? On the most basic level, government directs traffic: do we want to eliminate the regulations, signs, and signals that protect cars from colliding?

Every society makes some provision to safeguard its weakest members and share common resources. The U.S. right recognizes that defense is a legitimate public expenditure, prioritizing the world's strongest military over almost any other public function. But it is a commonplace to hear people who drive on publicly maintained streets, use city water and parks, send their children to public schools, collect unemployment insurance and Social Security—who partake in the full array of publicly supported social goods—speak of the public sector as an enemy of all that is good, beautiful, and true.

Two main factors account for this. First, the anti-government campaign has been loud, persistent, multivalent, and multiply reinforcing. So many individuals in highly visible roles have trumpeted it for so long, the message becomes normalized. When spokespeople assert government's essentially evil nature, they tend to do it on protected platforms such as in ads, on right-wing chat shows, and other places where no one equally likely to be heeded will interrogate their assertions, demanding proof and invoking the countervailing truth of private-

sector incompetence and malfeasance. To the contrary, in these venues, anti-government assertions are confirmed without needing to meet any standard of proof.

Yet it isn't at all clear that more give-and-take would make a significant difference. When resonant frames are hammered home, they tend to stick, being grounded in feelings, images and metaphors that aren't dislodged by mere information. With a government designed for Datastan, so many of our individual interactions are deeply unsatisfying, even embittering: have you applied for unemployment insurance benefits, tried to get straight answers to income-tax questions, or stood in line for hours for a driver's license? Then you know why the anti-government frame so easily takes root. As we have seen, even abundant evidence of corporate corruption and incompetence—corporations such as Goldman-Sachs acting contrary to shareholders' interests, for instance, often expecting to be bailed out by taxpayers, then paying executives huge bonuses—hasn't shattered the anti-government, pro-corporate frame.

The mystery for many who don't accept this frame is why people are thereby persuaded in such large numbers to vote and agitate against their own economic interests. The explanations that I commonly hear portray working-class far-right voters as dupes, lacking the necessary tools to see through the lies they've been fed. Sometimes it's gently stated, embedded in a critique of Fox News and its ilk, as if the conspiracy of lies were objectively impenetrable, rendering those duped by it blameless for their illusions. But however the analysis is expressed, the mood is dumbfounded: a simple calculation should convince working-class and middle-class voters to oppose policies that enrich the wealthiest at their expense. How could they be so stupid?

This is condescending, to be sure, and as a guide to persuasive political action, useless. It also assumes that political choices are based on calculation, when increasingly we are seeing how much emotion

figures into the process. I'm persuaded more by the conclusions of social psychologist Jonathan Haidt and his colleagues, who have researched the moral basis for political affiliations, finding that on the left side of the aisle, caring is a chief value, while loyalty, authority, and sanctity are not driving moral concerns. But on the right, they are more and more primary:

> Despite being in the wake of a financial crisis that—if the duping theorists were correct—should have buried the cultural issues and pulled most voters to the left, we are finding in America and many European nations a stronger shift to the right. When people fear the collapse of their society, they want order and national greatness, not a more nurturing government.[22]

Haidt has written that the left equates fairness with equality, while the right understands it as proportionality, so that the right is exercised by the idea of "welfare cheats," whom they see as benefiting without having contributed, while the left is far more upset by the unfairness of, say, billionaires who lobby to cut workers' wages and benefits.

Marshaling facts and figures won't change this, experts in framing tell us. But stories can. The Tea Party appropriated patriotic feeling by cleverly deploying early-American tropes, but it hasn't come close to exhausting the reservoir of historic imagery that can connect present-day voters with the powerful notion of a commonwealth and a common fate. When I ask myself why the liberal-to-left side of the political debate hasn't deployed such stories, the answer that arises is this: liberals are so committed to their idea of how politics works that they would rather fail in the familiar way than abandon it and risk failing in a new way.

The anti-public sector frame isn't only of interest at election-time. Everyone who cares about public education, stewardship, cultural

22 Jonathan Haidt, "Why working-class people vote conservative" guardian. co.uk, June 5, 2012. http://www.guardian.co.uk/society/2012/jun/05/why-working-class-people-vote-conservative

development, public health, environmental protection, and the myriad social goods under government's purview should also care about dislodging the anti-government frame. Shifting the frame (from Big Brother to a barn-raising, for instance) can only be accomplished in the realm of metaphor, where story, emotion, image, and resonance—elements of art, most effectively deployed by those who understand culture—are the most powerful tools.

15. Six Skills Intrinsic to Art Can Actuate Social Change

The popular uprisings in North Africa now known as the Arab Spring surprised almost everyone. In the fall of 2010, even the most reckless gambler wouldn't have risked real money on the prospects of overturning leaders who were expected to rule for life. Yet in the first months of 2011, they began toppling, yielding to public demands for self-determination, decent livelihood, and freedom of expression.

On January 25th of that year, as the revolt in Tunisia was ripening, I wrote an essay about Slim Amamou, a 33 year-old blogger, Twitter aficionado, and software developer who had been named Secretary of State for Youth and Sport in the interim government. I said that while it was true that social networking had been a powerful tool of the movement for freedom in the Mideast, the implications were larger than Twitter and Facebook. "This is a story about culture," I wrote, "about the centrality of culture to identity and self-determination, and about the unbounded world slowly being created by people who recognize this, and who can no longer allow themselves to be contained by those who don't see it."[23]

At the time, Amamou's Twitter stream was the object of much attention, including coverage in the *New York Times*. It revealed a vocabulary shaped by music and other cultural reference-points. For example, when he was denounced as a sellout for joining a government

23 http://arlenegoldbard.com/2011/01/25/ambassador-from-the-present/

that included some members of former president Ben Ali's team, Amamou replied this way: "It is similar to an underground artist who signs with a major label and is criticized by the purists and the masses." Amamou delivered a talk in September, 2011, at TedX Carthage, moving seamlessly from French to Arabic and back again, with a sprinkling of English tossed in. Some things are universal. When tech problems delayed the start of his talk, he vamped for time by singing a popular comic song called *"Chrigui bigui bgui baw,"* half in French and half Arabic—with half the audience singing along.

Within five minutes of publishing my tribute to the cultural revolution then beginning to unfold in Tunisia, Amamou sent me a message of thanks via Twitter.

Six skills were needed to actuate the Arab Spring, and all six are artists' core methods and essential habits of mind.

First, the young activists driving these nascent revolutions needed social imagination. This is the capacity to perceive existing reality clearly while rejecting the propaganda generated by every social order—*our way is the natural, the right, the enduring way*—in favor of imagining a much fuller, freer, more permeable set of arrangements, one that supports individual initiative and cultivates community. Human beings learn to see beyond what is to what could be by encountering difference. The people who drive change in most communities are those who've discovered alternate realities, often through creative depictions: books, videos, plays, music. Next time you read about a young activist in North Africa, try googling that person: very often, you'll find a blog, and within it, playlists featuring music that expresses the boundary-crossing liberatory spirit of the emergent world, suggesting horizons as broad as the planet.

Second, social transformation needs empathy, the capacity to feel something of another's experience and to cast oneself in the place of the other. The activists who filled public squares in Egypt and Tunisia

came from many walks of life and diverse social classes. They included numbers of technically savvy, multilingual, plugged-in young people who had not personally experienced the extreme pain of someone like Mohamed Bouazizi, the unemployed vegetable-seller who set himself on fire in December, 2010, outside a Tunisian government office, choosing to use the only thing he possessed—his life—to make a statement that echoed around the world. But instead of saying, *Oh well, it's not my problem*, they allowed another's story very different from their own, to enter their awareness and resonate with their own feelings, to ignite compassion leading to action. Google executive Wael Ghonim helped to spark a popular movement by sharing on Facebook the story of a single activist, Khaled Saeed, who'd been tortured to death by Egyptian police. The page's name was "We Are All Khaled Saeed."

Third, these activists need the ability to improvise, to face a situation that has no precedent, no blueprint or master-plan, to retain a sense of perspective and a connection to a central core of values, and to dance their way through whatever challenges may arise. They improvised communication networks, mass demonstrations, interim governments— and often, if their blogs, interviews, and tweets are to be believed, they did it with the sense of sacred play that is the essence of art.

Fourth, to change an old order, people need awareness of cultural citizenship and the aspiration to inhabit it fully. This is not citizenship in the narrow legal sense of papers and voting rights, but about the inner sense of belonging that allows us to feel that we are welcome in our society and community, that our contributions count, that our heritage and our expressions are respected. In many societies, even people who possess the right to vote feel keenly the extent to which they are denied the fullness of cultural citizenship on account of race, religion, ethnicity, economic status, or other characteristics seen as social deficits. The right to cultural citizenship is core to virtually all liberation movements; without it, what are you fighting for?

Fifth, in this new world, activists need connectivity: as many people have pointed out, their facility with social networking was a key factor in their ability to communicate and mobilize rapidly. Slim Amamou and others who were imprisoned in Tunisia attribute their release to online pressure. But it's not so much the method—the technology—as the understanding that any attempt to dislodge repression must be built on relationship, especially the person-to-person horizontal relationships that create community. Amamou and his colleagues were activists in the Pirate Party, an international coalition of democratic activists for whom net neutrality, universal, unrestricted internet access, and other expressions of freedom of information are key platform demands.

Sixth, above all, helping a new world to be born requires creativity, the ability to generate something fresh, which entails the innate capacity to face a problem, to see possibility arising from the broken scraps of the old answers, and to actualize it. It is far easier to tear down than to create something new. In a world morphing at light-speed into something none of us can foretell, fear and loss can be paralyzing. Creativity is the antidote: it is both our greatest challenge and our greatest need.

16. Art is Powerful in The Service of Social Change

Works of art have often moved public opinion on important social issues: Harriet Beecher Stowe's *Uncle Tom's Cabin*, the 19th century's best-selling novel, helped to ignite anti-slavery sentiment and action. John Steinbeck's *The Grapes of Wrath* opened readers' hearts to the plight of Dust Bowl refugees. Upton Sinclair's *The Jungle* exposed the meatpacking industry at the turn of the twentieth century, triggering the first major pure food and drug legislation. Costa-Gavras' popular films *Z*, *State of Seige*, and *Missing* catalyzed outrage at corruption and human rights abuses. Try to imagine the sixties civil rights movement in the American south without anthems such as "We Shall Overcome," or the anti-apartheid struggle in South Africa without music to march by,

without the powerful plays and novels that shone light on the protests and boycotts that eventually overturned that regime. More recently, hip-hop culture has arguably focused more sustained attention on injustices grounded in racism than have the headlines.

Sometimes art has been a singularly pivotal factor. For instance, Estonians used song as a primary form of protest against Soviet domination, sustaining spirit and solidarity in the struggle for independence. When they protested in other ways, Estonians risked their lives and freedom. Many paid a terrible price for resisting Soviet authority: long imprisonment in Siberia, torture, separation from their families, and more. But a longstanding tradition of song festivals—where choirs from across the country merge into a mega-chorus to jointly sing the folk songs they have separately rehearsed—provided the container and occasion for a less overt refusal to submit.

The movement became known as "The Singing Revolution." A film of the same name[24] contains remarkable scenes in which 300,000 Estonians (more than a quarter of the population) gathered on the Song Festival Grounds in Tallinn to proclaim their independence by singing the unofficial national anthem, "*Mu isamaa on minu arm*/My Fatherland Is My Love." In the late 80s and early 90s, inspired by the experience of the Song Festivals, Estonians put their bodies in the way of tanks, acting as human shields, singing for courage, succeeding without bloodshed.

Today in the United States, within the large and diverse movement to end this country's global status as Incarceration Nation, artists play pivotal roles. Thousand Kites,[25] a national dialogue project addressing the criminal justice system, is a collaboration between Roadside Theater and WMMT radio, two projects under the umbrella of Appalshop, a multifaceted community arts, media, and education center based in the eastern Kentucky mountains. The Thousand Kites project has produced

24 http://www.singingrevolution.com/
25 http://www.thousandkites.org/

a film, a play based on first-person testimonies from people affected by or involved in the system, a regular series of "Calls from Home" call-in radio programs for prisoners and their loved ones, and much more. The underlying idea is that while all of us are affected by the scale, expense, and human rights impact of our massive prison system, disseminating the facts hasn't done much to build awareness and action. But stories that bring the cost of the prison-industrial complex home have the power to ignite the caring that leads to action.

Around the nation, artists have responded to this issue in many way. Tony Heriza's and Cindy Burstein's film *Concrete, Steel, and Paint*[26] documents Cesar Viveros' beautiful mural, "Healing Walls: Inmates' Journey, Victims' Journey," the product of a collaboration between Philadelphia's Mural Arts Program, inmates, and victims of crime. The film shows how the collective creation of beauty and meaning opens a portal to healing for everyone involved, suggesting that such methods, widely applied, could transform a system that has forgotten what rehabilitation means. The Prison Creative Arts Project[27] at the University of Michigan works with performing and visual arts in correctional facilities, juvenile facilities, urban high schools, and communities across the state, sustaining a network of graduates who carry on the work around the country. These are just a few of many projects using art to awakening awareness and compassion in relation to the prison-industrial complex; collectively, they've reached and engaged many more people than conventional channels of news and public information.

And the same is true on every issue: I could cite countless arts projects focusing on the rights of women and racial and ethnic minorities, environmental action, human rights, economic justice, disability rights, and more issues than can be named.

26 http://www.concretefilm.org/
27 http://www.lsa.umich.edu/pcap/

17. Art Enables Collaboration Across Boundaries, Engaging Connection and Common Purpose

Many artists place their gifts at the service of democracy and community, often moving from a personal to a communal practice and back. The categories are fluid, but the work of these artists can generally be divided into two groups: those (like many of the writers and filmmakers mentioned in the previous section) whose work is about a social issue, and who hope to raise consciousness and lend support to social change by exposing certain stories and ideas to a wider public; and those whose work is both about social issues and deeply, intrinsically collaborative, pursuing social justice through form as well as content.

For instance, Andrew Garrison's 2012 film *Trash Dance*[28] portrays the yearlong collaborative, creative process whereby Austin, Texas, choreographer Allison Orr worked with employees at the city's Department of Solid Waste Services to create a dance performance conveying the power and grace of the essential work of carrying away the detritus of our lives. The solid waste workers' own movements as they go about their tasks formed the basis for the dance, which included a remarkable solo for an elephantine crane, as well as elements performed in a more conventional manner.

Orr (who is white) shows up in the film as open, present, real, and operating with total commitment. The Solid Waste Department employees featured there are African American and Latino, dignified, articulate, proud, wary, and equally committed to doing well in this shared creation. To work together, they bridge barriers of race and gender, embodying the human desire to see and be seen, to be treated as persons rather than things, to receive the acknowledgement and encouragement that lubricate civil society.

Don Anderson, a key character in the film, puts it this way: "We're not just these dirty people that pick up garbage. There is some grace to

28 http://trashdancemovie.com/

what we do." Later, he says, "I really thought about the importance of it, not only to Allison, but the way it would shed light on what it is that we do here, that it's not just collecting garbage or picking up trash. That gave me the inspiration of really wanting to give her a hand, to do my part in making her production a success."

Interviewed just before the dance premiered on an abandoned runway drenched by a daylong rain, Orr said, "It's about me setting up the possibility for people to show themselves and to show themselves to folks they may never ever see again in their lives in a really personal way, and for people to leave feeling more connected to each other, people that don't even know each other. Setting up an opportunity for all of us to be in this shared moment of 'What's Don's life driving that crane for those four minutes?' That's really what it's about."

There's a huge range of collaboratively created arts work, encompassing significant differences. But Orr's words express an underlying impulse core to The Republic of Stories: to enable people to tell their own stories with their own voices and bodies in their own ways, and to use those stories to illuminate larger questions critical to our collective well-being.

For instance, in 2011, I wrote a series of essays for the Harmony Project, sponsored by WomenArts.[29] They highlighted women artists whose work focused on collaboration with other community members, such as Meena Natarajan, Executive/Literary Director of Pangea World Theater[30] in Minneapolis, whose work centers on human rights. As an example, Meena described Pangea's collaboration with Minneapolis-based The Advocates for Human Rights, focusing on a dramatic work called *Journey to Safety: The Battered Immigrant Woman's Experience.*

I'll explain the trajectory of the work. The Advocates had a report called "The Government Responds to Battered

29 http://www.womenarts.org/harmony-project/introducing-harmony/
30 http://pangeaworldtheater.org

Immigrant and Refugee Women." We thought, wow, this would make an amazing piece of theater. And this report was also known among advocates, and so friends came to us and said this would be a great thing. We created the piece as an ensemble. I was principal writer, but the whole ensemble created the piece, an ensemble of about six women from different backgrounds, speaking six or seven different languages.

I also wrote about Rene Yung, a visual artist who has led a wide variety of participatory arts projects, many of them large in scale. For example, Chinese Whispers[31] is a multi-site community storytelling project about contemporary folk memories of the Chinese who helped build the Transcontinental Railroad and settlements in the American West. (I've acted as an advisor to the project.) Chinese Whispers: Golden Gate (the San Francisco-based project iteration) was launched with a February, 2012, performance and conversation based on oral history testimonies by Chinese Americans conveying their own experiences and those of their ancestors. The setting was a sound-and-image installation on the ferryboat Eureka, docked on San Francisco Bay as part of the San Francisco Maritime National Historical Park. Key stories included an account of the mid-1800's trans-Pacific crossing by six junks from a South China village, and first-person tales from the Bay Area's once-thriving Chinese fishing industry. As is typical in such collaborative arts projects, following the formal presentation, audience members shared their own stories touching on themes of family and sustenance, heritage and adaptation.

Each such project encompasses multiple reinforcing elements. In taking part in a project and sharing their own stories, participants (who seldom think of themselves as artists) have an empowering experience of self-expression and communication that often provides a portal to continuing cultural and communal participation. The work itself carries

31 http://chinese-whispers.org/

the power of truth as expressed by those for whom it has most meaning (in contrast to the reductive or dismissive ways participants' own communities or ethnic groups are typically portrayed in commercial culture). For audience members, witnessing resonant stories that reflect their own or their families' experience invites further sharing and involvement. Each project enlarges the circle of creators, building a bridge from often-marginalized communities to the larger society, and embodying the ethos of cultural democracy: pluralism, participation, and equity in cultural life.

I've written extensively about this work, most fully in my book *New Creative Community: The Art of Cultural Development*,[32] which is widely used to teach collaborative and community-based arts practice to university students and community members. All these projects make the same underlying point: that art can create a container for collaboration that crosses boundaries constraining other types of social interaction, finding connection and common purpose within diversity.

18. Art Can Connect Individual Stories to The Collective, Actualizing A Paradigm Shift

Moving from Datastan to The Republic of Stories is more than the aggregation of individual choices. Dorothy Day, founder of the Catholic Worker movement, famously said that "The greatest challenge of the day is: how to bring about a revolution of the heart, a revolution which has to start with each one of us?" A revolution of the heart is a paradigm shift in which our collective deck, our consensus model of the world, gets reshuffled, changing the story for everyone. In a revolution of the heart, those who have put themselves to sleep awaken, and healing begins to emerge where there has been harm. Such a revolution infuses the spirit of the times, so that even those unaware of precisely what is happening are able to sense that something new and important is unfolding.

32 Arlene Goldbard, *New Creative Community: The Art of Cultural Development*, New Village Press (2006).

How then do we link up our individual ability to shape our own defining narratives so that these stories form something larger than the sum of its parts, a revolution of the heart? One way is to cultivate artists' ability to perceive in an individual story the germ of a collective, catalytic story.

In *Community, Culture and Globalization*,[33] an anthology I co-edited, muralist Judy Baca, founder of the Social and Public Art Resource Center (SPARC) in Venice, California, relates a wonderful tale that shows how the transformative power of art can magnify the meaning of an individual story into something much larger and powerfully resonant. She tells the origin story of "The Great Wall of Los Angeles," the world's largest mural, painted by crews drawn from youth gangs. It portrays the buried history of California and its people, the dark layer that seldom makes the history books:

> The site was a concrete flood-control channel built by the Army Corps of Engineers. Once an arroyo (a dirt ravine cut by river water), the Tujunga Wash flood-control channel was an ugly concrete dividing line within the community with a belt of arid dirt running along either side. The Wash is in Studio City, a few miles north of Hollywood in the San Fernando Valley....
>
> The concreted rivers divided the land and left ugly eyesores, carrying the water too swiftly to the ocean, bearing pollution from city streets, affecting Santa Monica Bay and depriving the aquifer of water replenishment through normal ground seepage. In a sense the concreting of the river represented the hardening of the arteries of the land. If the river overflowing its banks regularly destroyed opportunities for the real-estate expansion that fast became the chief commodity of the fledgling city of the 1920s, then the river would simply have to be tamed.

33 Judith F. Baca, "Birth of A Movement," in Don Adams and Arlene Goldbard, *Community, Culture and Globalization*, The Rockefeller Foundation 2002.

These first decisions about the river made it easier to displace historic indigenous and Mexican communities in the name of city development....

The concrete river invaded my dreams, its significance becoming clearer to me as the correlation between the scars on a human body and those on the land took shape in my mind. Fernando, a charismatic leader from the original Las Vistas Nuevas team, was brutally stabbed in his own neighborhood's local store the summer of the painting of Mi Abuelita. He suffered 13 wounds to his torso and one to his face. We were devastated by the attack, but Fernando recovered and returned for the dedication ceremony, continuing his work against violence through the murals for many years until he was killed in his neighborhood park in the 1980s, 12 years after he had abandoned "the life." I asked him after he had healed how he was doing with the psychological scars left by such an attack and he responded, "The worst thing is that every time I remove my shirt my body is a map of violence." It was for this reason that I proposed and designed a series of tattooed images to cover and transform the scars on his body.

Standing at the river on that first day, dreaming of what it could become, I saw the concrete as a scar where the river once ran and our work in the channel producing the narrative mural, as a tattoo on the scar. The defining metaphor of what came to be known as the Great Wall of Los Angeles...became "a tattoo on the scar where the river once ran."

Every scar on the face of our cities and countryside has myriad counterparts in the individual scars we bear from our passage through Datastan, a world that expects us to adapt to its inhumane efficiencies, even if that means abandoning what matters most. In The Republic of Stories, they come together in the story field, linking with and

illuminating each other, revealing the patterns beneath the chaos, inviting us to follow our desire path toward healing. Depicted in art, one person's story can shine a light on thousands, converting private pains to public issues.

19. Pursuing The Public Interest in Art Expands Cultural Citizenship for The Common Good

Cultural citizenship demands no papers. In a situation of true cultural citizenship, each of us—regardless of legal status—is able to experience meaningful belonging, participation, and mutual responsibility. In a situation of true cultural citizenship, people learn about each other's heritages, respect each other's contributions to community life and public discourse, feel welcome in their own cities and towns. In a situation of true cultural citizenship, it is understood that all of us together craft the story that supports our collective resilience and ability to thrive—or else we fall prey to competing stories of triumphal superiority and bitter scapegoating, and in the end, no one thrives.

There are many ways to illustrate these things, but often when I think about cultural citizenship, my grandmother comes to mind. She was pregnant with my mother when she stepped off the boat from Russia at Ellis Island in 1914. Grandma was a small, ruthless person who had little interest in the world beyond her immediate relations, whom she dominated absolutely. But she was very different in the scene I am remembering, described in my book *New Creative Community: The Art of Cultural Development*:[34]

> I vividly remember my grandmother weeping in front of our
> little black-and-white 1950s TV each year when variety show
> host Perry Como (who was not Jewish) put on a yarmulke
> and sang *Kol Nidre*, a sacred Yom Kippur melody, during his
> primetime show each year. It took me some time to understand

34 *New Creative Community: The Art of Cultural Development*, pp. 227-228

that her tears had two sources: the pleasure of experiencing familiar and touching music in a highly public (even "all-American") context; and pain that this happened so rarely, perhaps no more than once each year.

My father served in the U.S. Navy during World War II; he and my grandparents proudly became citizens, taking care to vote in every election. Yet in the privacy of our own home, when speaking of our neighbors, we casually called them "the Americans," understanding that was an identity we would never be entirely welcome to inhabit.

I was born in this country, unlike my father, and I'm certain that to the casual observer, I present an image of utter assimilation. But my heart pounds when I feel impelled to remind colleagues that a glance at the Hebrew calendar before planning major conferences would avoid the offense of scheduling them on the holiest day of the year for Jews; or when I am called upon to help a young friend protest his school's decision to schedule Homecoming on Yom Kippur. Coldly calculated, I am fully a citizen, but the fullness of cultural citizenship is denied; indeed, the question of cultural citizenship is not even in the minds of those who unthinkingly shape my experiences of exclusion.

How much more so for my Latino neighbors, who have limitless opportunity to see actors of Latin American heritage portraying gang members and drug-runners, and almost none to see portrayals reflecting their own experiences and cultural values! How much more so every year, when our local police tangle with people on the street during Cinco de Mayo celebrations of Mexican independence, arresting numbers for jaywalking or drinking in public!

How much more so for my Muslim neighbors, who every day must face pervasive fear and mistrust which has nothing to do

with the actuality of their own social roles, their own desire to live in peace?

How much more so for my Pomo Indian neighbors when I lived in the northern California countryside, whose traditional grounds for the gathering of basket materials were flooded to make way for a man-made lake, without even lip-service to their cultural rights! How would your community be different if the same presupposition of cultural citizenship were given to every person as to its wealthiest citizens?

How would your community change if our social contract said this: *Let us proceed on the understanding that all of us belong here? Let us assert our collective right to occupy public space, to see ourselves reflected in sites of public memory, to feel at home in our own communities, to extend respect to our neighbors and receive the same in return, to honor our differences without losing sight of our common interests. Let us see ourselves as makers of culture, as subjects in history, and not its objects.*

Sometimes the assertion of full cultural citizenship is contested by people who feel that their own story—that this country belongs to white Americans who think as they do, and that their ownership confers the right to exclude, discredit and scapegoat others by any means necessary— ought to predominate. Consequently, they are willing to do anything to disrupt the counter-narrative of art and public purpose which is often the most visible assertion of the right to cultural citizenship.

For example, there is an ambivalent relationship between the mainstream artworld and the work of socially critical public artists, with repeated instances of artworks commissioned in the hope of eliciting an aesthetic frisson, then wiped out when the resulting shock was more powerful than anticipated. There are protests against censorship, to be sure, but in the end, the censors almost always prevail because in Corporation Nation, ownership trumps freedom of expression.

In 2010, Los Angeles' Museum of Contemporary Art commissioned the Italian street artist Blu to paint a mural on one of the museum's exterior walls; it was conceived as a prelude to the museum's April, 2011, exhibit on street art. The mural depicted repeating rows of caskets draped in dollar bills. Within 24 hours, it was whitewashed by representatives of the museum. When challenged, museum spokespeople made reference to two nearby monuments honoring veterans, suggesting that the image may have given offense by evoking the rows of flag-draped caskets associated with military deaths. But representatives of the neighboring veterans' organizations told the media that they had made no complaint.

The 2011 Sarasota Chalk Festival created a major cultural event by bringing both pavement artists and muralists to that Florida city for exhibits, installations, and conversations about their work. MTO, a French graffiti artist, created several works as part of the festival. During his stay in Sarasota, he was also one of five artists commissioned by the city's public art program to paint one wall of a parking garage. MTO's image depicted the hands of a local artist tattooed with the words "Fast Life" positioned so as to complete this sentence: "It's a fast life; let love express it." A campaign was launched against the mural, centering on the accusation that the hands were making a gang sign. In the end, despite a local police department ruling refuting the accusation, the mural was painted over.

Such incidents are part of a larger pattern in which countervailing iconography and viewpoints are erased from the landscape by those who command enough social power to control what others see. When it comes to cultural citizenship, some citizens are more equal than others.

Ownership of the cultural landscape is contested in many ways. The public debate over graffiti art offers an interesting illustration. Graffiti art—not tagging buildings and signs with one's initials, but using spray cans, stickers and other arts media to create complex works in public spaces—can be disturbing because it intervenes in the environment, disrupting expectations and often introducing unsettling imagery.

I've taken part in a quite a few forums and debates on the subject. The typical argument offered to oppose such works turns on two elements, private property and public consent. Opponents of graffiti art say this: "They don't ask for permission from the people who own the wall!" (Sometimes this is true, although many experienced graffiti artists make permission a point of pride and integrity; often its lack is merely assumed by people who can't imagine otherwise.) They also say, "Now I have to look at this, and nobody asked me if I wanted it there!"

In other words, when something unusual and unexpected pops up in public space, people instinctively assert some type of ownership of their surroundings, some right to have a say. This is a fine thing, and potentially, an awakening of cultural citizenship—or at least those aspects of citizenship that can be expressed as refusal.

What is so interesting about this is that we seldom bring that same quality of attention to the commercial occupation of public space. We are trained not to recognize it as a choice, not to notice that it is one in which most city-dwellers have no part. Imagine conducting two parallel studies: in one, ask random passersby on a major-city street to respond to a graffiti wall. In the other, ask why we allow businesses to fill public space with large-scale advertisements, some of which command us to consume certain products, some of which poke their virtual fingers into our insecurities in the hope of eliciting a purchase.

My hunch is that most passersby would simply accept commercial billboards and other large-scale public advertisement as "the way things are." But what if full cultural citizenship were activated in relation to public space? People would notice the entirety of their environments, including evident implications for cultural citizenship and social healing. They would see themselves as having the right not only to object, but to propose and contribute, understanding that the beauty and meaning encoded in their surroundings has a profound, pervasive effect on the texture of life and relationship.

While public art—murals, monumental sculpture, graffiti art, and so on—is often a flashpoint for censorship, public conceptual space is just as often contested. In June, 2012, the Library of Congress began its multiyear "Celebration of the Book" with an exhibition, "Books That Shaped America."[35] The National Coalition Against Censorship[36] reported that 26 of the 88 featured titles were banned or contested, as featured in the American Library Association's annual Banned Books Catalog.

It's ironic that the full import of works of arts often emerges into awareness only when they are seen as provocations, as grounds for conflict. When a film, book, or mural carries an impudent critique of the powers-that-be; or offends the guardians of a particular religious, racial, or ethnic identity; or takes indignant exception to an official history, it is easy to see how much people care about culture. When cultural citizenship is the site of conflict, it becomes clear how much the representation of themselves, their values, and their heroes matters, how much they feel is at stake.

20. Taking Cultural Impact Seriously Means Giving Culture Standing

In Datastan, cultural impact—the impact of our actions on a community's cultural fabric—is seldom considered in planning and policy decisions. The results are written across our landscape. From the 1950s onward, many American cities invested in a neutron-bomb style of urban development, where historic neighborhoods were leveled and troublesome populations cleared away to make room for a new freeway or sports stadium.

Such decisions are vetted. But conventional assessment focuses on environmental and economic impact. If developers can provide credible assurance that endangered species will not be harmed, if they

35 http://www.loc.gov/today/pr/2012/12-123.html
36 http://ncacblog.wordpress.com/2012/06/22/banned-books-the-shaped-america-at-loc/

can provide convincing cost-benefit analyses, there remain no grounds to halt a project that obliterates a tapestry of relationships, sites of public memory, generations of roots and aspirations, leaving in place a downtown wasteland no one visits unless there's a stellar attraction at the shiny new performing arts complex.

For many decades, Datastan perceived "urban renewal" as a valid response to urban problems: if a neighborhood is plagued with street crime or deteriorating infrastructure, simply excise it. The failure of these interventions was pointed out by Jane Jacobs in *The Death and Life of Great American Cities*,[37] still as refreshing to read as when it first came out more than a half-century ago. The following paragraph appeared in my chapter of a prizewinning anthology on contemporary uses of Jacobs' ideas:

Planners and policy makers commonly prescribe measures for others they would find intolerable in their own lives, such as the wholesale practice of relocation, which Jacobs calls "slum shifting" and "slum duplicating." Faced with the multiple discontents of a low-income housing project, planners "build a duplicate of the first failure and move the people from the first failure into its expensive duplicate, so the first failure can be salvaged." I try to imagine the fantasies of the public housing authority director who devised such a scheme: that the bleak uniformity, cheap construction and non-existent amenities of a housing project would magically add up to a decent place to live, if only they were made new and fresh?[38]

How would your community's face be different if culture had standing, if the lives displaced and cultural fabric destroyed by redevelopment were taken into consideration? What if there were a

37 Jane Jacobs, *The Death and Life of Great American Cities*, Vintage Books (1961)

38 *What We See: Advancing the Observations of Jane Jacobs*, New Village Press 2010. http://www.newvillagepress.net/book/?GCOI=97660100041170

national requirement for a "cultural impact report," analogous to an environmental impact report? Campaigning to require EIRs was one of the first ways the environmental movement infused daily life with ecological awareness. I expect requiring a CIR would similarly raise cultural awareness.

The CIR would assess the impact of public actions such as new construction of public buildings and freeways. What would be the likely human and cultural cost of a proposed project? What would be the likely cultural benefit? Are there ways to mitigate cultural impact? Alternative ways to accomplish the project's goals with significantly less deleterious cultural impact?

Until a community's cultural fabric has legal standing, we'll keep on making those same inhumane and short-sighted "urban removal" decisions over and over again. Whether the instrument is a CIR or some other intervention, the exodus from Datastan requires us to raise broad public awareness of the importance of culture, the right to culture, and the public interest in cultural development. Public-policy instruments are one way to do that.

21. Putting Artists to Work in Cultural Recovery Can Catalyze A Larger Recovery

Imagine the impact on American society if 120,000 artists were employed this year in institutional and community settings, doing the kind of work I described earlier in parts 16 and 17.

During the New Deal of the 1930s, President Franklin Delano Roosevelt's response to the Great Depression included major programs to employ artists. The longest-lived were grouped under the heading "WPA" for Works Progress Administration, a huge employment relief program started in 1935 at the beginning of FDR's "Second New Deal." They made up Federal Project Number One, comprising five divisions: the Federal Art Project, the Federal Music Project, the Federal Theatre

Project, the Federal Writers Project and the Historical Records Survey, together employing more than 40,000 artists by the end of its first year, when the U.S. population was about a third of today's.

Saul Bellow, Thomas Hart Benton, Katherine Dunham, Zora Neale Hurston, Jacob Lawrence, Arthur Miller, Louise Nevelson, Mark Rothko, Orson Wells, Eudora Welty, Richard Wright, and thousands of other artists were associated with the WPA.

The New Deal included programs addressing unemployment and development in many sectors, from agricultural price supports to infrastructure projects. The stimulus they provided raised both personal expenditures and Gross Domestic Product every year. More than 75 years later, the federal arts programs of that period are the most familiar and beloved part of FDR's legacy. They persist in memory as symbols of the entire New Deal because they generated so many powerful images and stories embodying the spirit of the times. As the nation moved toward economic recovery, these arts projects helped to bring about cultural recovery, reframing the moment from one of isolation and despair to one of partnership and possibility.

Since World War II, more and more artists have worked in community cultural development (sometimes called "community arts" and illustrated by the work described earlier in section 17). They collaborate with others to express concerns and aspirations, illuminating history and heritage, beautifying neighborhoods, teaching, expressing cultural creativity as a universal birthright and a bottomless source of resilience. They are midwives of The Republic of Stories, where arts-based approaches to education, healthcare, environmental protection, and other social responsibilities help communities to realize their fullest potential and make the most of their resources, typically creating large impacts in proportion to costs. Because this practice is driven not by market considerations but by the desire for cultural connection, for expressive opportunities, and for recognition of all contributions to

local and national history, it constitutes a social good rather than a market-driven commodity. By definition, it flourishes most in times of public investment.

In the 1970s, community artists and arts organizations took advantage of public service employment programs through the Department of Labor, notably CETA (the Comprehensive Employment and Training Act). At its height, CETA invested approximately $200 million per year (over $800 million in 2012 dollars) in jobs for artists teaching, performing, creating public art and administering arts programs in the public interest. Until Ronald Reagan abolished them, these programs were a mainstay of the community cultural development field; almost every community artist active in those days either had a CETA job or was close with someone who did. Many of today's most accomplished practitioners and most-admired organizations were helped by CETA to pursue the democratic interest in cultural life, promoting vibrant cultural citizenship rich with cross-cultural sharing, creating murals and other public art commemorating community history and pride, making works of dance and theater that deepen and refresh understanding, telling stories that heal, devising opportunities for young people to express themselves and learn through artistic practice.

Luis Alfaro, Judy Baca, Peter Coyote, Bob Holman, Geoff Hoyle, Bill Irwin, Spike Lee, George C. Wolfe, and thousands of other artists were associated with CETA.

Then and now, sustainable recovery is rooted in communities' own awareness both of challenges and of whatever supports resilience and healing in challenging times. Artists are uniquely able to help people unearth the stories that stimulate social imagination, to cultivate creativity, connection and strength through community projects that generate beauty and meaning. Today, as always, sustainable national recovery demands cultural recovery. But the news hasn't yet trickled up to Datastan.

A few months after President Obama took office in 2009, I co-led a delegation of more than sixty community artists and creative activists to a White House briefing where we heard about the administration's openness to collaborating with artists on our great collective project of national recovery. We held a pre-briefing meeting not far from the White House. It included (among others), writers, filmmakers, dancers, hip-hop activists, muralists, educators, organizers; people who—like myself—are first-generation Americans; people descended from slaves; people whose parents worked on farms or in factories or had trouble finding work at all. We were so excited about being there that most people arrived well before the appointed time. We got confused and started the meeting half an hour early: we had to stop and start again!

By the time a few months had passed, our excitement had subsided. We understood that in the prevalent political climate, even a Democratic President facing enormous unemployment wasn't going to risk political disapprobation by advocating for a public service jobs programs. So although even halfway measures are perceived inside the Beltway as undoable at the moment, opportunities are ready and waiting for political will to arise.

For instance, it wouldn't be necessary to start by creating a special-purpose initiative like the WPA: public funds now set aside for information leaflets no one reads and PSAs no one watches could be repurposed to employ artists to bring public policy goals to life. It's been proven, for instance, that grassroots theater is an effective way to convey health information, relating it to community members' own lives and challenges. Indeed, in developing nations around the world, what is usually called "Theater for Development" is recognized and valued as an effective mode of learning and engagement for people affected by pervasive challenges such as the lack of clean water, or the HIV epidemic—people who cannot be reached with nifty leaflets and public service announcements, but must be engaged in real relationship.

Sadly, the extent of need cannot compete with Washington's inside-the-Beltway calculations. Given this reality, I do not think the first steps toward actualizing what we now know about artists' essential roles in national recovery will be taken by elected or appointed officials. Instead, if and when this happens, it will be the result of popular support, and that will gather in other ways, not through conventional political channels. Meanwhile, I entertain myself by imagining the messages that might help to awaken a sense of possibility.

In one imaginary creation, I see an old woman sitting on a porch swing or overstuffed couch with a youngster, a great-grandchild. "That's right," the woman is saying, "when I was your mother's age, I had a job working on plays with something they called the Negro Theater Unit, right here in Oklahoma. And the government paid for it!"

"The government paid for you to be in the theater, Grandma Lee? Are you kidding?"

The woman shakes her head no.

"Why?" asks the youngster.

"Those were bad days for everyone," the woman says, "and black people were hit hardest, right in the middle of the Dust Bowl. They knew we had to tell our stories, that would help us get through it and figure out what to do. They knew we had to pass our stories along."

"What do you mean?" asks the youngster.

"It's like in slavery times," says the woman. "Sometimes, when things are hardest, all people have is their stories. The memory of better days, the hope of a future."

"And artists give them that?" asks the youngster.

The woman nods. "Artists give them that. Look at this country. We need to remember our stories, and just like when I was young, artists will be ready to help us again."

"Maybe you should tell the President about it," the youngster says. "I think he forgot."

22. Art Can Also Be A Powerful
Form of Spiritual Practice

In English versions of Deuteronomy, Psalms, Proverbs, and Lamentations, the Hebrew bible's references to the pupil of the eye are almost always translated as "the apple" of the eye, symbolizing what is most precious, most in need of safeguarding. "Keep me as the apple of the eye, hide me under the shadow of thy wings," reads Psalms 17:8.

Literally, though, the Hebrew text reads "*bat ayin*," "daughter of the eye." This is uncannily close to the English word's Latin original, *pupilla*, a diminutive for child. Why was this ocular feature given that name? When we gaze into another's eyes, our own image is reflected in miniature. To remember who we are, we look into another's eyes and see ourselves looking back.

But very often, remembering is hard. It is easy to get distracted by daily obligations and requirements, and the world shrinks to the size of a to-do list. There are many ways to talk about the dual nature of existence. I like the Zen Buddhist terms small mind and big mind (and their exact Hebrew equivalents, *mochin d'katnut* and *mochin d'gadlut*), referring to the mind that sees distinctions, barriers and separation versus the encompassing mind that sees everything as a unity, as beyond comparison. We humans have to live in the world of small mind, because life calls upon us to make countless distinctions in the course of each day: green means go, red means stop, and to ignore that invites peril. But if awareness is shaped by knowledge of big mind, of our absolute connectedness, we don't get stuck there. This comes through clearly in art, where a particular story told in a particular way opens a window on universal questions also affecting our own lives and indeed, all life.

Like many in my generation, I am sometimes a spiritual seeker, exploring teachings associated with my own Jewish heritage and other spiritual paths. Often, these lead me to my true spiritual home, which

one might call the Church of Art. When we read about the wellsprings of theater in ancient Greece, for instance, we are told that the Dionysia— the first theater festival on record—was simultaneously an art practice and a spiritual practice. The same can be said of so many artists' work in these times and at every moment in between, especially those works that offer a sense of possibility in a time of constriction.

The great 18th century teacher Rebbe Nachman of Bratslov said: "The antidote to despair is to remember the world to come." We can't remember what has not yet occurred, but I think he meant that despair yields to a glimpse of a perfected world in the experiences that remind us of what it is to feel entirely alive.

When we transcend the specific circumstances of our lives, diving headlong into the stream of creativity, even mundane things—even the focus, diligence and practice of craft that sometimes feel like drudgery— can be lifted into pleasure by remaining aware of their higher meanings. The most powerful way to remain open to the widest spectrum of information from body, intellect, emotion, and spirit is making art. In the flow of creativity, human beings are resourceful, imaginative, playful, embodied, empathetic, excited, alive. Making art, we inhabit ourselves fully; we are at once most godlike and most human in experiencing the pure possibility of creation. What's more, artistic practice is a powerful way of reframing experience, changing its meaning from something fixed and obstructive to a new vision of possibility.

Mostly, reframing is seen as a practical technique, a way to work with political meanings embedded in voters' minds. But it is also a form of spiritual practice. My friend Rabbi Burt Jacobson has made a deep study of the teachings of the Baal Shem Tov, Rabbi Yisroel ben Eliezer, the 17th-century rabbi considered the founder of the mystical tradition of Hasidic Judaism. A key learning from the Baal Shem Tov is a three-part process of transforming pain and adversity:

1.) *HACHNA'AH*/Surrender;

2.) *HAVDALAH*/Discernment; and,

3.) *M'TIKAH*/ Sweetening (or Transforming)[39]

In essence, the process is to accept the reality of suffering, rather than yield to the pervasive denial Datastan inculcates; to discern the wisdom and possibility latent within suffering; and thus to enable a sense of freedom to arise in the place of obstruction.

Every person has a reservoir of stories—ancestor stories, origin stories, stories from childhood — that help to shape the defining narrative of that individual's life. If any of us is burdened with a version of our story that pinches or chafes, all we need do is turn it a little—to reframe it—and another facet comes into view.

I know this from personal experience. At a low point in my own life, my inner story made me very sad: I felt sure that the pains and obstacles I had suffered were punishments, but I did not know what I had done to deserve them. I tried and failed to ignore or minimize my misery, and finally I faced it. Whether through luck or providence, I was given a book of spiritual teachings that suggested an alternate way to see my life-story. It led me to consider how my feelings might change if the experiences I'd understood as punishments had instead been understood as preparation for the unique tasks I was to fulfill. Simply by facing that question, I began to discern possibility. As I stuck with it, I felt as if my personal narrative were a deck of cards, and all in an instant, the deck had been reshuffled, dealing me a whole new hand.

Whether with an individual or a collective story, the opportunity is the same. What might be seen as a social movement can also be seen as a spiritual awakening. The present moment—a passageway between paradigms—offers such an opportunity. We can be part of a shift in human history, in which the things that have been shunted off to the margins—beauty, meaning, reflection, creativity, facing loss and finding resilience—in which these important things will at last be rescued

39 http://www.claudionaranjo.net/pdf_files/festschrift/Festschrift.pdf

from Datastan and given their true value. Necessity and creativity can collaborate. Forms of work not previously recognized as having social utility can emerge as worthy, in part because the old jobs are disappearing, necessitating a redefinition of work, and in part because we come to understand the value of investing in creative capacity. New creative technologies can emerge to seize public attention as older technologies will be repurposed, but not forgotten, expanding our stock of tools for social creativity.

Whatever happens, art will foreshadow, portray and interpret it, lifting countless lives from the merely bearable into beauty. Will the work we do to effectuate this change be artistic practice, or will it be spiritual practice? My answer is yes.

23. Art Can Enable Social Healing of Collective Trauma and Its After-Effects

The effort needed to move our actually existing society from its current predicament in Datastan's grip to The Republic of Stories—a place where true cultural citizenship is a fact of life—can be characterized as social healing. Explore any American city and you will find countless rips in the cultural fabric, sore places where people have been made to feel less than fully entitled to respect, even less than fully human. Here, healing is needed.

The same principles apply to social healing as to the healing of individual trauma. Through the work of psychologists as through the healing legends of many cultural traditions, we have learned that it can help a traumatized person to tell his or her story in fullness and in detail, but only if the telling is received with an open mind and heart. We know that individual abuse makes a person feel disrespected, used, harmed, shamed, blamed, worthless, and expendable. These same insults typify the collective trauma inflicted by invidious discrimination based on age, race, gender, ability, sexual orientation, class, and other characteristics.

When we tell our stories, if we experience anything resembling those insults, the injury will be compounded rather than soothed. For healing to begin, the story must be received with respect, presence and caring.

Many artists have devoted themselves to helping to heal those injuries. I was deeply touched by Eric Okdeh's mural, "Forgiveness,"[40] at 13th and Erie in Philadelphia, commissioned by the City of Philadelphia Mural Arts Program. The artist describes it as "inspired by the selfless acts of forgiveness by Janice Jackson Burke and her son Kevin Johnson." Kevin Johnson was shot and paralyzed by two young men who wanted his basketball jersey. Over time, mother and son made the choice to forgive the attackers, forming relationships with them. Kevin passed away in 2006. Adults in Graterford Prison and young men in Saint Gabriel's Hall met with Mrs. Burke, working together with the artist to conceive the mural's design. "Through these extraordinary meetings," the artist writes, "the inmates were able to hear firsthand the grief of a victim of violence, and Janice was able to come to know men who were imprisoned for life." This beautiful mural quotes from Rembrandt's painting of The Prodigal Son, creating a powerful narrative of healing and redemption, one that offers every resident and passerby the opportunity to reflect on the toll violence has taken in their own communities, and the personal choices that can strengthen our collective ability to end it.

Nancy Kelly and Kenji Yamamoto's film *Trust: Second Acts in Young Lives*[41] depicts the process whereby Chicago's Albany Park Theater Project works with a group of teenagers to depict the story of one young girl who was molested and abused in her home country of Honduras, and who finds healing through sharing the story in a safe and caring context. The drama turns on one girl's experience, but it reaches tender places and evokes deep feelings for the entire group of performers, mostly immigrants and first-generation Central Americans and African

40 http://www.phillymuralpics.com/photo-galleries-1/north-philly-2/img-0540.html

41 http://trustdocumentary.org/

American kids who live in surrounding neighborhoods. When the play is performed for family members, neighbors, and classmates, the circle of connection expands.

The Silence Speaks[42] initiative of the Center for Digital Storytelling in Berkeley works with people around the globe to craft and share stories of surviving violence, abuse, armed conflict, and displacement. Participants are helped to craft their own narratives that tell their own deepest truths in powerful ways, then turn them into short videos with spoken word, music, and images that are shared via websites and screenings. Among the project's partners have been Sonke Gender Justice in South Africa, connecting gender, violence, and HIV; Go Joven in Central America, training youth leaders focused on reproductive rights and health; and SAATHI Nepal, a group dedicated to ending violence and injustice against women.

When handled in this way, such stories have a holographic effect: while the specific details are unique to a particular individual, a powerful impact is felt at every point on an ever-expanding grid. As audiences are affected by the story, individual healing multiplies, becoming social healing.

24. Art Can Heal Brain Function

At the 2010 American Association for the Advancement of Science Conference, Harvard neuroscientist Dr. Gottfried Schlaug explained that brain-damaged individuals can regain the power of speech through singing.[43] "These interventions are very useful to stroke victims," he said. "Music is a good medium to get parts of the brain responding that are not responding."

Dr. Schlaug is Director of the Music and Neuroimaging Laboratory, originator of many studies on making music and brain function. By now,

42 http://www.silencespeaks.org/
43 http://www.telegraph.co.uk/health/healthnews/7285154/AAAS-Singing-helps-stroke-victims-relearn-language.html

they've compiled a large body of research documenting music's efficacy even for healthy and normal brains.

For instance, one study showed increases in important aspects of brain volume and in the connection between left and right hemispheres in musicians.[44] In another, Schlaug found that in children taking music lessons who practiced at least two and one-half hours a week, a region of the corpus callosum that connects two sides of the brain grew about 25% relative to overall brain size, and that growth directly predicted their improvement on a test of planning and coordinating movement. In other words, investing serious time in making music measurably improved other capacities. In an August, 2012, symposium on "Music, the Brain, Medicine and Wellness" Dr. Shlaug documented his methods of using music to teach otherwise silent autistic children to speak. Consider this scene from the symposium:"

> Perhaps the most striking moment of the symposium came when Gottfried Schlaug of Harvard Medical School and the Beth Israel Deaconess Medical Center revealed the results of an approach he has developed, called auditory-motor mapping training, using pitch and rhythm to heal autistic children who are incapable of speaking. A video camera captured a boy, almost 5 years old, at various stages of the treatment: Although unresponsive at the beginning, after 10 sessions he suddenly uttered a word: "bubbles." It was the moment at which his parents heard his voice for the very first time.... After 40 sessions, he was speaking simple sentences as well as his name. As this progress played out on screen, a gasp went up from the entire audience. It was a dramatic example of how music is now being employed to revive dormant pathways in the brain.[45]

44 Greg Miller, "Music Builds Bridges in the Brain, *Science Now,* April 16, 2008, http://news.sciencemag.org/sciencenow/2008/04/16-01.html

45 Stuart Isacoff, "With Music on Their Mind," *Wall Street Journal,* August 8, 2012. http://online.wsj.com/article/SB10000872396390443991704577577001 430372414.html

In 2009, Columbia University's medical school in New York launched a Master's Degree program in Narrative Medicine, described as fortifying "clinical practice with the narrative competence to recognize, absorb, metabolize, interpret, and be moved by the stories of illness." Think about it: a major university has made this level of investment in exploring and engaging stories' power to heal; this is a significant indication that art's public purpose is emerging into visibility.

Alive Inside is Michael Rossato-Bennett's 2012 nonfiction film about music and healing.[46] Before it was released, a clip went viral via YouTube. It shows Henry Drayer, a man whose usual state is nearly somnolent: day after day, he sits in his nursing-home wheelchair, staring and unresponsive, his face an impassive mask. But everything changes when he is given an iPod filled with the music he loves, largely Cab Calloway and other jazz artists of the first half of the twentieth century. The music awakens Drayer: he sings, and miraculously, he responds to questions. Before our eyes, he transforms from an avatar of resignation into a fully dimensional human being, crackling with life.

Neurologist Oliver Sacks, who features prominently in the film, describes the man as "restored to himself. He has remembered who he is, and he has reacquired his identity for a while through the power of music." Drayer is asked what music does to him. "It gives me a feeling of love," he says. "Right now, the world needs to come into music, singing. You've got beautiful music here.... I feel a band of love and dreams." The film showcases the Music and Memory project,[47] which makes personalized iPods available as healing instruments to people shut in at home, in nursing and assisted living facilities, in hospitals, and in hospices.

A few months earlier, *The Music Never Stopped*[48] was released. This narrative feature film was based on an Oliver Sacks story, "The Last

46 http://www.ximotionmedia.com/
47 http://www.musicandmemory.org/
48 http://themusicneverstopped-movie.com/

Hippie," about a young musician who has been robbed by a brain tumor of the capacity to make new memories. He reawakens and reconnects with other human beings—including his estranged father—through the mostly sixties-psychedelic music he adores, especially The Grateful Dead.

It can be hard to get to truth now with words alone, because there is so much background noise. But music can cut right through the noise. No doubt, scientists are even now "explaining" why this is so. I am not saying the scientists' version is inferior or untrue; it is one true story that can and should be told. But it can never encompass the entire truth: does naming brain chemicals, electrical charges, and memory mechanisms convey all there is to say about a parent's love for a child? Or the thing that makes you feel that someone you have just met will be important in your life? Human beings are animals whose physical mechanisms conspire with unparalleled genius to generate emotional states. But we are also much, much more.

The people depicted in these films have hitched a ride to their true selves through music. Their experience expresses it better than anything else could: by braiding beauty and meaning, by simultaneously activating all four realms of experience—physical, emotional, intellectual, and spiritual—music permits us a glimpse of wholeness, and when we give that glimpse its true weight, it can be sustaining.

This has always been true. It is not new. What is new is the emergence of this deep and ancient truth into the realm of science, disrupting the old paradigm's certainties about so many things. What is healing? How are the body and spirit connected? What happens when beauty and meaning are understood as medicine, when we remember that reaching the whole, fully dimensional, fully sensual person carries a power that can never be equaled by the mechanistic, dry-as-dust interventions of the old paradigm? Datastan gives way to The Republic of Stories.

25. Art Can Enlarge Professional Perception, Capacity, and Vision

In a 2010 *New York Times* op-ed,[49] Wes Davis described how in 1952, top executives at Bell Telephone began to be concerned about the scope of managers' education. It was put this way: "A well-trained man knows how to answer questions; an educated man knows what questions are worth asking." The president of Bell Telephone in Pennsylvania was also a university trustee. With academic colleagues, he created "the Institute of Humanistic Studies for Executives." This was an immersion program: ten months on campus, 550 class hours. Guest lecturers included W. H. Auden, Delmore Schwartz, R. P. Blackmur, Lewis Mumford, Virgil Thomson, and David Riesman. Participants read and discussed James Joyce's *Ulysses*.

The program was intensively evaluated. Participants reported heightened curiosity, awareness, ability to see more than one side of questions. One executive is quoted as having seen himself before the program as "a straw floating with the current down the stream." "The stream was the Bell Telephone Company," he wrote. "I don't think I will ever be that straw again."

Yet, Davis wrote, "Bell gradually withdrew its support after yet another positive assessment found that while executives came out of the program more confident and more intellectually engaged, they were also less interested in putting the company's bottom line ahead of their commitments to their families and communities. By 1960, the Institute of Humanistic Studies for Executives was finished."

Today, the world of commerce is engaging with the same opportunities—and reservations. Perhaps today's motives are more practical than liberal: particularly pivotal is the sensible notion that in

49 Wes Davis, The 'Learning Knights' of Bell Telephone, *The New York Times*, 15 June 2010, http://www.nytimes.com/2010/06/16/opinion/16davis.html

a remarkably fluid business environment, advantage rests with those who've developed creative capacities. A 2010 special issue of the *Journal of Business Strategy* was devoted to "Arts-based learning for business." The editors note that top-selling business writer Daniel Pink's idea that "The MFA is the new MBA" was named by *Harvard Business Review* as one of its breakthrough ideas of 2004, while at roughly the same time, NHK, Japan's public broadcasting network, "identified arts-based learning in business as one of the ten most important emergent trends of the twenty-first century."[50] The issue featured ten articles by practitioners of arts-based business learning, from those who teach collaboration through music to those using visual art to develop skills of discernment and reflection.

The overview article is by Nick Nissley, who was then Executive Director of the Leadership Development program at the Banff Centre in Alberta. He quoted a number of business leaders, including Donna Sturgess, Global Head of Innovation at the pharmaceutical corporation GlaxoSmithKlein:

> We have found that art-based tools help teams to see beyond the obvious to generate new ideas. Adventures through art give us more transformative experiences where new ideas emerge and our awareness is heightened to see beyond the obvious. Attitudes and influences on our thinking are made visible and our imaginations are stimulated. Art teaches business the ability to conceptualize and to push beyond the established norms and boundaries.[51]

50 Guest editor(s): Harvey Seifter and Ted Buswick, *Journal of Business Strategy*, "Creatively intelligent companies and leaders: Arts-based learning for business," Volume 31 issue 4, 2010

51 Nick Nissely, "Arts-based learning at work: economic downturns, innovation upturns, and the eminent practicality of arts in business," in the *Journal of Business Strategy*, Volume 31 issue 4, 2010

Nancy Adler of McGill University in Montreal was mentioned earlier in connection with the inclusion of an art history course in medical students' training at Yale. She is one of the leading scholars of arts-based business practices. In a highly influential 2006 essay, she wrote:

> Designing innovative options requires more than the traditional analytical and decision-making skills taught during the past half century in most MBA programs. Rather, it requires skills that creative artists have used for years.[52]

Adler's and many other essays on the subject of art and business feature compendia of quotations; the footnotes are sometimes longer than the texts. It would be easy to pile up quotes like this. But it wouldn't be altogether honest, because, as the editors of that special *Journal of Business Strategy* issue wrote, "Over the past 18 months, in the wake of the global financial crisis, it has become far more difficult to forge new learning-based arts-business partnerships, launch new arts-based learning projects in corporations, or even complete existing programs."

This hasn't changed since. The editors described how, under economic pressure, companies have cut back on such programs even as some of the nonprofit initiatives created to advance this work have folded. As with the leaders of Bell Telephone back in the fifties, the enlarging value of culture has been proven. In a milieu dominated by short-term, bottom-line thinkers, the cost is still thought to outweigh it. But given the scale of need and potential benefits, it shouldn't.

26. The Burghers of BP: Art Can Heal The Economy's Broken Stewards

For many months following the 2010 BP oil spill in the Gulf of Mexico, Rodin's sculpture, "The Burghers of Calais," regularly popped

52 Nancy J. Adler, "The Arts & Leadership: Now That We Can Do Anything, What Will We Do?" *Academy of Management Learning & Education*, 2006, Vol. 5, No. 4, p. 489.

onto my mental screen. You may have seen it: there are more than a dozen casts from the 1895 original in museums and other collections around the world.

The sculpture depicts an incident during the Hundred Years' War. In 1347, the English King Edward offered to spare the starved and defeated city of Calais if six of its leading citizens would emerge from the gates to surrender their lives, along with the keys to the city and its castle. A wealthy and prominent figure, Eustache de Saint Pierre, volunteered first, and five others followed suit.

The six gaunt, distraught, and nearly naked life-sized male figures are loosely grouped, nooses dangling from their necks, bare feet firmly planted. The figures are bronze, but there is a palpable sense of vulnerability, of having been stripped not only of clothing but of personal power, so that the metal somehow speaks of the softness of pale flesh unused to exposure. The figures radiate defeat and humiliation, but also courage and nobility, creating a fragile and uneasy balance that never quite seems to settle. In "The Burghers of Calais," the powerful have surrendered all their trappings of position. They stand ready to sacrifice themselves for the greater good.

The first time "The Burghers of Calais" surfaced in my mind, I was looking at a Reuters photo of BP's chief executives that appeared in *The New York Times*. [53] Chief Executive Tony Hayward, Chairman Carl-Henric Svanberg, and Managing Director Robert Dudley—three men in their fifties—stand side-by-side. Hayward, his mouth in a tight half-smile, gazes pointedly out of the frame. Svanberg, in profile, turns toward him. Dudley, a little apart on the right, faces straight ahead. His mouth is twisted slightly to one side; his eyes seem to turn inward.

53 "BP's Blueprint for Emerging From Crisis," *New York Times*, July 27, 2010; the photo by Toby Melville is captioned "From left, Tony Hayward, the chief executive of BP; Carl-Henric Svanberg, the chairman; and Robert Dudley, the managing director, outside BP's headquarters in London on Tuesday."

All three are wearing elegant, expensive blue suits with the sheen of summer-weight silk, white shirts with starched collars. Hayward and Svanberg sport bright blue ties—the repeating pattern on Hayward's is larger—while Dudley's tie is a dull red silk. Each man's hair is expensively cut and arranged in a style appropriate to its texture; all of them have thick, healthy, tanned skin, a subtle, sunny glow. They stand before a radiant backdrop, bright pale green at the base, the color of new leaves above.

The three executives don't look delighted to be there, but neither are they in obvious distress. As a visual object, the photograph is surprisingly beautiful, especially for a wire-service image of a press event: a feast of light and texture, all wanting to be touched. All surface. Nothing is revealed. You and I could read into it any meaning we wish, but the meaning that emerges most clearly from the mountain of related media coverage is a remarkable disconnection from the consequences of one's own actions.

Why does this photograph remind me of "The Burghers of Calais"? I suppose because the two works are polar opposites: power in service to others, power serving itself.

I am not a Buddhist. But I am often engaged in with questions central to Buddhist thought: desire, suffering, the connection between them. There is no better way to describe those willing to sacrifice Mother Earth for personal profit than the Buddhist concept of "hungry ghosts." Although this powerful spiritual concept incorporates many complexities, its core is captured in an elegant and succinct description by psychotherapist Mark Epstein.[54]

> The Hungry Ghosts are probably the most vividly drawn metaphors in the Wheel of Life. Phantomlike creatures with withered limbs, grossly bloated bellies, and long thin necks, the Hungry Ghosts in many ways represent a fusion of rage

54 Mark Epstein, *Thoughts Without A Thinker: Psychotherapy from a Buddhist Perspective*, Basic Books, 2004, p.28

and desire. Tormented by unfulfilled cravings and insatiably demanding of impossible satisfactions, the Hungry Ghosts are searching for gratification for old unfulfilled needs whose time has passed. They are beings who have uncovered a terrible emptiness within themselves, who cannot see the impossibility of correcting something that has already happened.

When I read that, I think of the kings of Corporation Nation who have money enough for a hundred lifetimes—indeed, the scale of whose wealth attests to the fact that their hungers cannot be satisfied by material possessions—and whose desire for more, channeled into business aggression, has obliterated the simple human compassion they would otherwise feel for those who've been made destitute and miserable by their decisions. This is the brokenness of Datastan.

Any antidote to this malady, to the plague of greed and indifference that has had such profound and distorting impacts of our common culture, must turn on art, because to heal our economy and its broken stewards, we must heal our capacity for self-knowledge, empathy, imagination, and social creativity. I'm not attributing magical powers to art, or suggesting that any art experienced in any way will do the trick. If that were true, just being an artist would provide inoculation against such distortions, and there would be no hungry ghosts among art stars and celebrities. The antidote is specific: deep engagement with art that awakens, encounters, and nourishes awareness and compassion.

In the world of commerce, the power of art—of creative imagination, storytelling, image, and metaphor—is beginning to dawn, although as explained earlier, a tight focus on short-term profit has limited willingness to invest in cultivating art's power. But awareness is growing. IBM's 2010 biennial CEO study, *Capitalizing on Complexity*,[55] was based on interviews with more than 1,500 CEOs and managers from both the

55 *Capitalizing on Complexity: Insights from the Global Chief Executive Officer Study*, IBM Corporation, May 2010

private and public sector in 60 countries and 33 industries. It revealed that the "single most important leadership competency" needed to navigate an environment of escalating complexity was creativity. The study said that

Creative leaders invite disruptive innovation, encourage others to drop outdated approaches and take balanced risks. They are open-minded and inventive in expanding their management and communication styles, particularly to engage with a new generation of employees, partners and customers.

Underlying this call for creativity and relationship is the study's report that "Most CEOs seriously doubt their ability to cope with rapidly escalating complexity." There is a growing consensus that it will not be possible to adapt, innovate, and prosper in the current environment by relying on the familiar and comfortable. Many leaders now understand the need to create organizational environments that embody and encourage the imperative of creative risk, moving people beyond their comfort zones to engage the new world they must face. As the IBM CEO study reports:

CEOs recognize that leading creatively will require them to shed some long-held beliefs. Their approaches need to be original, rather than traditional. They must be distinct and, at times, radical in their conception and execution, not just marginally better than existing models or methods. Or, as one Telecommunications CEO in India put it: "Creativity in everything."

There are many accounts of leaders engaged with these questions experimenting with a range of approaches to building collaboration, from wilderness ordeals to ropes courses to learning-directed games. These ideas embody the desire to deepen working relationships and cultivate innovation. But they attempt to satisfy that desire with something that cannot support the necessary transformation of corporate culture.

Coworkers who test themselves in nature or enjoy themselves in play may experience singular moments of connection or awareness. But these can't add up to the necessary cultural transformation, because none of them can go to the heart of the matter, generating a sustained, growing, integral experience of creativity.

Instead, the best and most powerful answers to these questions have been discovered in the realm of artistic creativity, because it is through our ongoing engagement with cultural expressions that we learn empathy and imagination, the indispensable ingredients of a humane life, humane business, a humane society.

As described in "The World is Upside Down," the terrible imbalance in Corporation Nation is a problem that affects us all. When I hear the latest scandal of financial corruption, self-dealing, rent-seeking at everyone else's expense, the nobility of "The Burghers of Calais" seems distant and unattainable, the actions of a different species. But the latent capacity remains to re-infuse these broken lives with empathy, imagination, and creativity in the service of care. All that is required to activate it is choice.

27. The Search for A Sustainable Future is Pointing Toward The Skills and Habits of Mind Associated with Art

Imagine Datastan and The Republic of Stories as two tectonic plates, rubbing each other the wrong way. Arguably, the earthquake's epicenter is the marketplace and its control-room is the corporate office. Freud thought human civilization was forged in conflict between the pleasure principle (our desire to experience what is pleasurable) and the reality principle (delaying gratification for necessary accomplishment). This conflict can never be resolved, he believed, but will always tip towards suppression of pleasure in the interests of civilization.

A quick tour of any shopping-mall (virtual or bricks-and-mortar) makes his point. We have developed numberless ways to channel desire into purchasing-power and aggression into conspicuous consumption and economic competition. We are geniuses at creating and consuming the simulacra of pleasure without finding much deep or lasting pleasure in them, ensuring that we will be hungry to buy more soon. As Freud observed, the machinery keeps ticking over, fueled by the suppression of our true capacities.

But Freud's diagnosis can make sense without granting the predictive power he claimed for it. Is sublimation of pleasure the inevitable price of human society? In his 1955 book *Eros and Civilization*, Herbert Marcuse said no, proposing that in developed societies, human beings can recognize and correct the repression of their true natures, making the human body an instrument of pleasure rather than labor (pleasure being understood within an expansive idea of Eros that includes art and imagination as well as sexuality).

Marcuse's book was framed as a response to Freud's philosophy, and so in some important ways was bounded and shaped by what he chose to criticize. He could not foresee how those boundaries would burst. A decade later, in a new introduction written in the thick of the sixties sexual revolution, Marcuse saw people crossing every social barrier to interact sexually, exercising unprecedented liberty, but sadly, without noticeable healing effect on our national habits of subjugation and suppression.

It is possible to have sex without engaging Eros, to eat without tasting, to see the world in shades of black and white and lose the memory of color, to choke off emotion and fail to perceive the distortions thus created, to borrow and adapt others' ideas and call it creativity.

But the opposite is also true. In "The World is Upside Down," I ask you to imagine yourself at a corporate conference table, to experience the suppression of full human dimensionality that is practiced there.

But of course, each of us at the table has the ability to notice feelings and sensations, to bring our full dimensionality—our full capacity to perceive and communicate in physical, emotional, intellectual, and spiritual realms—into the workplace, increasing our ability to be present and respond. Will we?

Possibility is ripening. A turning-point has been reached, a moment in which there will be a choice to cease subjugating so much human capacity in the interests of a particular type of order, because the benefits of full presence outweigh the risks. In attaining this understanding, my text is neither Freud nor Marcuse: I have been reading the world of human experience, and attempting to share with you what I see written there, between the lines as well as on them. In Corporation Nation, two truths are converging. More and more, leaders are recognizing that how we have been operating is unsustainable, causing untold human and environmental damage. It has also become increasingly evident that the old assumptions that underpin Corporation Nation's *modus operandi* have expired, so that even some former true believers are ready to release their grip, to seek new insights and approaches. That search is pointing toward the skills and habits of mind associated with art.

As I write this, storytelling is the rising star of business practices. Living as we are—camped out on the bridge between paradigms—the public and nonprofit sectors tend to be behind the curve when it comes to social innovations. In Datastan's climate, being "businesslike"—an idea shaped by past incarnations of business—is the prerequisite to being taken seriously, even if your work has nothing to do with business per se. Foundations and government agencies, asserting their legitimacy in a time that questions their right to exist, are still mostly enraptured with metrics and benchmarks, insisting that numbers are the best language in which to convey value—even social value, even aesthetic value.

But among the most exciting thought-leaders in the business sector, we see a growing recognition that the obsession with metrics distorts

perspective, pushing people to serve the numbers (the business equivalent of the pervasive "teaching to the tests" now distorting education); and that success is all about relationship, which is subtle, fluid, human, and subjective. Business thinkers are urging businesses to tell stories; to hire people with the skills of improvisation and imagination; to learn how to listen and cultivate connection; to privilege meaning over metrics. Mega-corporations in Big Oil, Big Pharma, and the war industry are rooted firmly in Datastan. But it's only a matter of time before smaller and more flexible, more market-driven corporations change the culture, until nonprofits and government catch up with The Republic of Stories.

28. Already Becoming:
The New Paradigm Is Hidden in Plain Sight

As with all such shifts, the new understanding of art's public purpose doesn't entail a change in reality so much as in our ability to perceive what is already true. Wherever I travel, for instance, I see streets full of people plugged into their iPods. This has been denounced in tones of moral panic: we are isolated, we don't talk to each other anymore, and so on. An insistent drumbeat condemns our use of new technology as a distraction from human life and social intercourse.

But I see its meaning as exactly the opposite: I think we are self-medicating, prescribing for ourselves music that attunes our bodies, feelings, minds, and spirits to precisely the support, inspiration, beauty, and meaning that will sustain us through life's challenges. When we want to express identity, understand each other better, connect to sources of strength, find inspiration, create pleasure, celebrate and commemorate peak moments, we turn to music, dance, drama, still and moving images. Whenever we human beings have free choice in how we use our time, for a huge number of us, the choice we make is art.

Right this minute, as preposterous as this may sound to those whose vision is blurred by the tainted grain of commercial media, we are poised

on the cusp of this paradigm shift. The conventional discourse about art and culture is like the notion of a flat earth: it can no longer contain even a fraction of what many of us have always known and what experts are just now proving to their own satisfaction about art's astonishing power. The new model of reality is emerging, however much it is resisted by those who cannot yet surrender their attachment to the old one.

More and more of us perceive this emergent reality every day, but there is a powerful social pressure to ignore it, to go along with the idea that Datastan is the best of all possible models, and to accept the price we pay for citizenship in that narrow nation: being treated like a number, choosing obedience over pleasure, accepting that our pathetic educational and medical systems (for instance) are the best we can do. This is nothing more than a defense, nothing more than Datastan's operatives whistling in the dark and pretending to see strength where weakness dominates, a last-ditch effort to shore up something that is even now giving way.

My question is whether those of us who have seen the emergence of The Republic of Stories can push past Datastan's pressure to remain silent, standing to proclaim our truth. Now is the time to ignore that pressure. What would it take for you to drop any anxiety or embarrassment you may feel about seeing the world clearly in a time when a great many other people are in the grip of a distortion? I urge you to try it on in your imagination, to experience the release of adopting a way of understanding and speaking about art's transformative power that is fully consistent with seeing the world clearly.

In the spring of 2012, I watched an episode of Stephen Colbert's program on the Comedy Channel. His guest was writer Katherine Boo, who had a new and acclaimed book about people living in extremely impoverished conditions in sheds and lean-tos on the grounds of the international airport in Mumbai, which is one vast slum. Colbert asked her this: "When you go there and spend three years living with people

who are by our standards abjectly poor, what does America look like to you when you come back?"

"It looks incredibly fixable," she said. "I come back here and I think, oh, if we were really serious about fixing poverty, we could do it in like half a second."

What arises in your mind when you hear Katherine Boo's response? My first reaction was to agree. An instant later, the smug face of my internal antagonist popped above my mental horizon. "So simplistic," he said. "So naïve. Our problems are much more complex than that."

Whenever I hear that voice—and I hear it just as often on the news or in some journal or on a website as in my own mind—I am reminded of the biblical story of Na'aman, a brave and victorious captain of the army of the king of Aram, who happened to be a leper. A young Israelite girl he'd captured for a house-servant told his wife that Elisha the prophet, living in Samaria, would heal her husband. So Na'aman sets out to Elisha's house to ask for healing, trailing an entourage of horses and chariots bearing many gifts. Elisha refuses to see him, instead sending a message: "Go and wash in the Jordan seven times, and your flesh shall be restored, and you shall be clean."

Na'aman is offended, having anticipated a remedy commensurate with his own importance. He says, "I thought, he will surely come out to me, and stand, and call on the name of the Lord his God, and wave his hand over the afflicted place, and cure the leper." But bathing in the Jordan seems a little insulting. "Are not Amana and Pharpar, rivers of Damascus, better than all the waters of Israel? May I not wash in them, and be clean?"

With that, Na'aman storms off, furious. His servant, daring to follow him, puts a question: "Sir, if the prophet had told you to do something difficult, would you not have done it? How much more should you do it when he has only said to you, Wash, and be clean?"

Reluctantly, Na'aman dips himself seven times in the Jordan. The story tells us that "his flesh was restored like the flesh of a little child, and he was clean."

These ancient wisdom stories have a lot to teach, basic lessons in understanding that have stood the test of time. How often do we reject the simple truth out of an inflated sense of our own importance? How often do we question even the things we feel most deeply, because we are surrounded by talking heads and experts who tell us that what we feel doesn't count, that we are naïve or uninformed, or simply not smart enough to understand? Human beings have the largest brains, proportional to body size, of any living species, and far too often, we waste all that intelligence. We spend it constructing in our own minds the defenses we vainly hope will protect us from disappointment, and shaping the self-denying beliefs that deprive us of the power to act on what we know.

Now here comes the simple thing: Who are you? What do you stand for? How do you want to be remembered? Whatever your answers, whatever your invisible antagonist's reaction to those answers, once you have them, you will know the part that is yours to play in actualizing The Republic of Stories. Wave good-bye to Datastan; say hello to The Republic of Stories.

The World Is Upside Down

Most nice afternoons when I'm not on the road, I walk along a stretch of the San Francisco Bay Trail near my apartment in Richmond. I enjoy the changing cast of birds and beasts, the play of light on water, the warm sun on my shoulders, the breeze tickling my ears. If I'm alone, I almost always listen to an audiobook or to my most recent music playlist. Often, on another channel in my mind, I turn over a question or re-examine an experience that earlier captured my attention. My walk makes a refreshing break in a long day at the computer. Almost always, I return home feeling better than when I left.

I usually smile at the people strolling or speeding by on their bicycles, and many of them smile back. "How ya doin'?" "Enjoy your walk!" African American and Southeast Asian men fish from the harbor steps or the beach as their children play nearby. More men each month: unemployment, I assume. Most are young and able-bodied: how else do they have so many hours to fish on a weekday afternoon? They can't all be working the night-shift. As they hold up their catch, I hope they've read the boldface signs posted along the way: bright-colored pictures of fish are labeled "Eat This: Less Chemicals" or "Don't Eat This: More Chemicals." (The California Water Quality Monitoring Council lists the following "contaminants of concern" in local fish: mercury, PCBs, dieldrin, DDT, chlordane, and dioxin.)

The route I take most often loops around the inner harbor, then down the coast, returning via a meandering path along a creek. At certain times of year, a Great Blue Heron hangs out where the creek makes a turn. I think it's the same bird depicted in the series of photos

I've taken with my phone, but I suppose they could be siblings or just lookalikes. On the harbor across from my place, Night Herons stand motionless for hours. They resemble overstuffed bluebirds; I always want to reach out and stroke their downy backs.

My neighborhood is built on land that used to be part of the Kaiser Shipyards where Liberty Ships were made during World War II. A big piece of this land is still unfit for building on account of industrial waste buried far beneath the surface. Nowadays, with the factories gone, the surface is landscaped and lovely. There are rocky slopes leading down to the bay. Wallflowers, Clarkia, poppies, and other blooms line the walk. Once I counted a flock of more than 90 pelicans flying past. I love the slow way they flap their dinosaur wings, the big *plop!* when they drop into the water.

There are small monuments and signposts every so often, bearing photographs and testimonies from the mostly African American and Latino workers whose northward migration to work in the shipyards and factories changed Richmond from white and rural to highly diverse and urban. The newcomers were invited here to be part of the wartime workforce, but many of their testimonies speak of Jim Crow practices encountered in local businesses and housing, taking the shine off a promised welcome.

A special focus is "Rosie The Riveter," paying homage to the women whose first good jobs—for some of them, their last good jobs—were in the war industry. Back in those days, Richmond had a thriving downtown, with shops, clubs, and restaurants. Now it often seems immune to economic development, enduring successive failed schemes to incubate local business in the central-city ghost town. When new acquaintances hear that I live in Richmond, they always ask if it is safe. One central neighborhood has the region's highest murder rate. There's a changing population of new immigrants in the surrounding streets: mostly Central American and Southeast Asian now, rubbing up against

longtime African American streets, generating the friction that marks every place where the dispossessed and displaced are tumbled together. The higher up into the hills you go, the larger the houses and gardens, the whiter the neighborhood.

On most of my walks I see a pale red-haired woman who appears to be in her eighties pushing an ancient little dog in a pram. When the weather is cool, the dog is tucked up under blankets. Other dog-walkers stop to visit with her: a tall African American woman in her thirties with an even taller hairdo and a tiny Yorkshire Terrier; a Japanese-American couple with two Scotties; an Indian man who never smiles and his Golden Retriever, who seems friendly enough; a middle-aged white guy whose hair matches one of his otherwise identical dogs, Standard Poodles in white and chocolate brown.

Almost all the houses and apartments in this neighborhood were built at the same time: developers were given permission to build in return for remediating the coastline, so it all looks fairly uniform and oddly suburban for the context. It is diverse (more than 40 percent of residents speak something other than English at home) in part because in a region where housing values tend to be sky-high, Richmond is relatively cheap, so people can settle here who might not be able to afford nearby Berkeley. The big family groups I see while walking are mostly Latino, many from the very different neighborhood on the other side of the freeway, full of single-family houses with small yards, but without parks and playgrounds. They come on summer Sunday evenings to picnic on a little stretch of beach; and many times each month to play soccer on a large flat lawn which seems to be the only workable soccer-field in the vicinity.

Families low on the slope toward upward mobility surely recognize that Richmond's public schools and other amenities are perceived to be substandard. It appears that most of those seeking a place to live around here accept as given that there are good and bad public schools, and

you must purchase the privilege of sending your children to the good ones. They understand that homebuyers expect to pay a premium to be near good schools, and if they can't afford the premium, they live with the second-rate.

This is a defining question for the future of life in the United States: how to build a bridge from the mesmerizing comfort and diversion still possible in private life to facing overwhelming collective challenges? In the personal space of so many lives (including mine), there is scope for pleasure, for beauty and delight, for connection and freedom. Yet right beneath the surface, the evidence of distress simmers and bubbles. It is hard to encompass both realities in a single awareness, but if there is any hope of a livable future, it is necessary.

How can it be done? My answer is that the matrix in which both private and public reality are suspended is culture; the way we comprehend and link both realms is through culture; and the arena for our interventions is culture.

Not everyone knows this yet. I meet people all the time who have lost their way to the bridge between realities, who find themselves perpetually circling one domain like planes that can't land. I met a man whose life is focused on bees, a profession that brings him into constant contact with environmental threats created and exacerbated by human beings: climate change, the rapid spread of viruses and parasites to a population weakened by pollution. Any conversation-opener—"Seen any good movies lately?"—will cycle back to the same despairing question: we are destroying the life of this planet, and why does no one do anything about it? In some sense, the pleasure of living has been foreclosed: his field of vision is fully occupied by reasons to despair, and without really wanting to, he is filtering out a great deal

that might lift him out of melancholy into joy. What he sees is true, but not the whole truth.

I met a woman for whom the little world of friends and family is everything: she ferries her children to lessons and play-dates; shops, cooks, and cleans; relaxes in front of the TV; has Sunday dinner with her siblings and their children, midweek lunch with friends, and most of the time left over is for things like eating and sleeping. When I asked whether the summer's extreme weather had affected her garden, she said, "Do we have to talk about politics all the time?" The small, happy world of her family begins to feel unbearably fragile as soon as she is asked to see it in a larger context. True citizenship has been foreclosed by the narrow privatization of experience; her refusal to face what lurks beneath the glossy surface of private life makes her an island rather than a citizen. What she sees is true, but not the whole truth.

Pioneering sociologist (and sixties activist) C. Wright Mills wrote of the American proclivity to treat public issues as private troubles. Shame attaches to unemployment or illness, easing our slide into the groove of self-blame. "What did I do to deserve this?" easily turns into blaming others: "What did they do to deserve this?" Meanwhile the larger truth—that fates and deserts are seldom linked by controllable causes—is ignored. The workers who migrated from the deep South to Richmond for jobs building Liberty Ships owed their livelihood to the suffering of war, to industrial expansion, and to the social ferment of the 1930s that produced the North's somewhat greater willingness to receive people of color. None of their individual shortcomings caused the jobs to go away. But the pain when work disappeared was borne by individuals and their families, and very often regarded as evidence of personal failure. Collectively, Americans seem remarkably committed to the primacy of private life, to keeping a tight enough focus on the little world that many of the ways the big world impinges are blurred into peripheral invisibility.

The brokenness to be read between the lines of my beloved afternoon walk doesn't lessen its beauty, nor does it obliterate the pleasure my neighbors and I take in the experience. But it points to a common cause, which is the consistent privileging of profit over other values—individual and community well-being, a flourishing ecosystem, access to social goods such as education, decent livelihood, and so on—and a pervasive acceptance that this is just the way things are.

When social problems are seen as extremely convoluted, multifaceted, and resistant to solutions, they are dubbed "wicked problems." This phrase is used by planners and systems theorists to describe complex and singular predicaments without easily defined alternative resolutions or clear boundaries. They are connected to or embedded in other problems, so that pulling on any thread leads to a Gordian knot of complications. When wicked problems take up residence on the grand scale of a society, they are sometimes called "social messes." Racism is a social mess; so is the current economic crisis. But Corporation Nation subsumes them all. It is a social mess that has spread to encompass every aspect of the public good, sacrificing public well-being to private profit.

Economist Gar Alperovitz describes our current system as "corporate capitalism," distinguishing it from a free-enterprise, free-market, or socialist system. This description is from his keynote address to the 2012 Green Party national convention:

> The way you define the system is who owns the capital wealth, and one percent owns just about half of all the investment business capital, one percent. Five percent owns 70 percent. And the top—this is a number you've got to get your head around, really odd and I checked many times—think about this, the top 400 people, not percent, people, 400 own more wealth now

than the bottom 185 million Americans taken together. That is a medieval structure. I don't mean that rhetorically, I mean that technically that is the way you concentrated wealth in the medieval era, really.[56]

Like all social messes, it's hard to bring this one into clear focus. It isn't so much a matter of how much the top few own—although hearing regular bulletins on our increasing polarization of wealth and ownership has been like watching a slow-motion disaster movie—as the failure of vision, imagination, and compassion that has stolen so much from the bottom many.

I can heap up numbers here, but why bother? Do I have to convince you that in the United States today, something is very wrong with the culture we have created? Wealth can insulate one from the consequences of living in Corporation Nation, supporting the illusion of a protected private life—and of course, wealthy or not, there is pleasure in living regardless of the political or economic climate. But more and more, it is impossible to avoid paying a price for the dominance of corporations. It can be discerned in the commercialization of absolutely everything including the conversion of many social goods to private profit centers. It has devastated civil society, with whole sectors lumbering along zombielike, mostly dead but not yet ready to lie down: private prisons, corporate-run schools, the runaway power of Big Pharma and Big Oil. Any meaningful sense of commonwealth is being hollowed out, and the shell is being piped full of what former World Bank economist Joseph Stiglitz characterized as "rent-seeking," which is profiting without contributing. For example:

> The most dramatic example was the predatory lending and the abusive credit card practices, which took money from people

56 http://www.garalperovitz.com/2012/07/on-democracy-now-my-keynote-address-to-the-2012-green-party-convention/#more-1192

on the bottom and the middle often in a very deceptive way, sometimes in a fraudulent way, and moved it to the top.[57]

Public policies encourage this behavior by taxing speculative rent-seeking at far lower rates than ordinary wages. Private interests devise ways to maximize it. Over the last forty years, Corporation Nation has become committed to short-term profit; raising the bottom line for stockholders has taken clear precedence over all other goals—not just social goals, but business goals such as plant modernization, waste reduction, workforce stabilization, and sustainability.

Alperovitz, Stiglitz, and many others have written excellent treatises on these developments and the economic damage they have wrought. My subject, though, is culture, the matrix in which an economy takes root. In committing this country to corporate culture—its systems of organization and valuation, its inherent attachment to uniformity, standardization, and ever-larger scale, its depersonalized notion of social responsibility, its quantification addiction, and its self-serving rationales—we have dehumanized our civilization, corrupting what is most beautiful and nourishing to civil society. Many of us have forgotten how to feel fully alive. We have set ourselves a devastating course to a future widely feared.

Not all of us may be able to name this national headache, but nearly all of us feel the pain. What is amiss is inscribed in the texture of daily life: easy to notice once awareness has been triggered, disheartening, and in the remarkable and pervasive complexity of its manifestations, hard to fully comprehend.

I want us to rescue culture from Corporation Nation, making full use of artists' redemptive skills, perspectives, and ways of seeing and acting before the point of no return is reached.

57 http://www.foxbusiness.com/personal-finance/2012/07/03/is-wealth-gap-hurting-all-us/

In a landscape crammed with signs and reminders, why do I pick art as the lever that can pry the lid off this trap? In the animal kingdom, indicator species are seen as a kind of early-warning system, as sentinels alerting us to an imminent threat from disease or climate change: oysters and mussels are bio-monitors for marine environments, for instance. Among human beings, we artists function as an indicator species.

It is no small thing that in the process of national corporatization, artists' social value has been miniaturized to near-invisibility. A key factor in corporate success is that human pleasures are channeled into optimal modes of consumption: they must require a purchase, rather than be accomplished with our own bodies, feelings, minds, and spirits. To exploit the market, they must offer options for different income-levels, but regardless of cost, their potency should fade quickly so that each acquisition triggers the need for a fresh one. People's own cultural heritages must be devalued in favor of a commoditized American culture constructed of an idealized past and a product-placement future. Within this framework, a steady drumbeat must keep us feeling *less than*, lubricating the system with our anxiety, stimulating perpetual hope that our malaise can be cured with the right purchases.

In contrast, when it comes to culture, everyone owns the means of production. Certain human experiences are universal—birth, rites of passage, death—yet we mark them in extraordinarily distinct ways grounded in inherited customs and perpetually adapting to emergent reality. What we eat, how we adorn ourselves and our dwelling-places, the signs and symbols we use to communicate, our sense of the ineffable and what we may owe it—these and more are all elements of culture. To be sure, the commercialization of culture is part of Corporation Nation's larger agenda, just as are the commercialization of food production, medical care, childhood, and countless other social goods. But among them, it has distinct meaning: in essence, art and other forms of cultural expression are the practice of freedom. How they are treated testifies

to social well-being. And their latent power is enormous, because they contain the raw material of rebellion and connection that will allow us to outgrow and throw off Corporation Nation.

This shift has two inseparable parts: the task entails both greatly enlarging our understanding of art's public purpose and importance and greatly reducing corporate domination. Although the official story may see the two as unrelated, the relationship is actually close and dialectical: even as the privatization of public issues obscures this reality, artists' skills of social imagination, improvisation, empathy, and resourcefulness are needed to break Corporation Nation's grip on our collective sense of the possible, to overturn the inherited powerlessness that consigns the many to live as subjects of the few.

I've given many talks to groups of artists, educators, and those who support their work. I used to approach my subject as a participant-observer, sharing tales of remarkable arts projects and offering critiques and proposals touching on public cultural policy. I cared a great deal about what I was saying, but I spoke of it as *out there*, at a distance.

Half a dozen years ago, some barrier dissolved and the distance evaporated. I remember very clearly the first time this happened. I was asked to keynote a conference of the National Guild for Community Arts Education. The Guild's members run community music schools and art centers where tiny kids study Suzuki violin and adults learn to dance or teens take photography lessons. Member organizations are a diverse batch, from the elite to the grassroots and back again.

As I planned my talk, I knew that I had to take the risk of speaking about what mattered most to me, rather than crafting a presentation based on some notion of what people wanted to hear. At that time, I was deeply involved in spiritual study and practice. Certain truths were

flinging themselves against the door to my mouth, wanting to be let out. The talk I gave was entitled, "Higher Ground: Community Arts as Spiritual Practice."

I'm seldom nervous before a talk; I enjoy public speaking and usually feel pretty relaxed on the dais. But on that day, my heart pounded, my hands sweated, and I took to the stage hoping my voice wouldn't break. It was a short talk, twenty minutes or so. Gazing around the room during the lovely ovation at the end, I saw many people wiping their eyes and noses. They were still weeping when they rose to comment during the Q&A.

They weren't unhappy; indeed, I hadn't told a single sad story. I recognized their tears as the outward sign of inward relief and validation. You see, the room was full of people—some of whom had labored for decades in total commitment to their missions—who'd become masters at sustaining themselves with hope and dedication through a period of repeated budget cuts, a period in which their work had been devalued by politicians while the need and demand for it grew exponentially. Many were locked into defensive stances, determined not to show their fear and pain to the mostly young people who treated their organizations as sanctuaries in an otherwise chilly world. They'd undertaken their work out of passion and conviction, but after years of Sisyphean labor, they'd begun to doubt their own deepest truths.

Our hearts encode the words we long to hear: *you are loved, you are valued, you are forgiven*—whatever our deepest desires. My heart is inscribed with the message I yearned to utter that day and every day since: *what you know to be true is true. What you know of your work's value is true. What you are doing is even more important than you have understood.* Hearing it allowed the audience members to cry. Ever since, when tears of recognition follow one of my presentations, I take heart.

A cynic might accuse me of pandering: an audience of defense contractors would want to hear that they are making this country safe; an audience of hospital administrators would want to hear that they are saving lives. An audience of bankers would welcome the unapologetic assertion that they keep the economy afloat. Each of these groups is sometimes vilified by critics and reformers; each would welcome such validation as an antidote to the defensiveness this might provoke. But each is also powerful, respected, and well-funded. Categorically, their self-esteem is high. Stroking it would be likely to elicit smiles, not tears. In that distinction, there is a world of difference.

Artists make up a small portion of the workforce. Although they possess the power to affect and influence others, most of them lack economic and social power. I don't see artists as superior to other people, nor do I see their gifts as necessarily more or less socially valuable than other types of skill and vision. As individuals, they have the same freedom as other human beings to be honest or not, caring or not, responsible or not, and they probably fulfill those potentials at the same rate as any other category of workers. Countless artists use their gifts to enrich business owners—writers and designers in advertising agencies, video games designers, industrial designers, the composers of sitcom soundtracks and elevator jingles. It may well be that more artists labor on the creative-sector equivalent of assembly lines than in studios and communities. What I have to say here doesn't have much to do with their day jobs.

But there is a sizable population of artists—performers, composers, visual and multimedia artists, filmmakers, writers, and others—whose work is driven by desire to add to the world's stock of beauty and meaning, and who are often willing to make great sacrifices to continue doing it. Many of them are on some sort of crusade, wanting to bring attention to sights, sounds, and acts that have something to teach but are so often overlooked in an information-rich, high-speed society. I count myself in that category.

Many of them regard the same stories, images, and practices that others pass by in the course of a day not as trivial evidence of ordinary lives, but as the material of art, as tributaries of a wellspring of human creativity, stories waiting to be told, imagination waiting to be nourished, beauty waiting to spring out of its hiding-place into plain sight. I count myself in that category, too. And while I reject romantic notions about the exceptionalism of artists as a class, I am certain that the artists I have just described have an essential and special role to play in this society's future.

In the introduction to my book *New Creative Community: The Art of Cultural Development,* I made reference to a November, 2005, *New York Times* article by Alan Riding: [58]

> ..."In France, Artists Have Sounded the Warning Bells for Years." He interviewed filmmakers and musicians who long ago warned of explosive social conditions in the banlieues (literally "suburbs," this word has come to signify impoverished immigrant neighborhoods dominated by high-rise public housing). Quoting lyrics and citing films, Riding pointed out that in contrast to artists, who felt the pulse of the times, consistently predicting what was to come, newspapers and politicians "have variously expressed shock and surprise, as if the riots were as unpredictable as a natural disaster."

The examples before and since are numberless: wanting to understand the spirit of the times, seeking street-level insight, wanting to know how our neighbors are reacting to the emergence of possibility or the imminence of disaster, a deeper truth will be discovered by consulting what people are listening to, watching, creating, and how they are moving than by consulting any pundit or pollster.

There is also another sense in which artists serve as an indicator species. Examining how a society treats its artists—especially those whose

58 Arlene Goldbard, *New Creative Community: The Art of Cultural Development,* New Village Press 2006.

work touches on social observation, commentary, or imagination—reveals a great deal about its values and priorities. It's a synecdoche: the treatment of artists symbolizes social value and meaning as a whole.

In the United States today, there is a small class of artists who are obsessively glorified, worshipped, and valorized. Photographers camp outside every building that certain actors and musicians occupy, hoping to catch sight of glamor or of clay feet—almost any glimpse suffices to feed the gaping maw of the gossip industry. While they remain in the limelight, these celebrities are paid fabulous sums, and the makers of designer clothing, jewelry, and other accoutrements of the rich and famous vie to reward them with perks in hope of a few frames of free publicity. Just so, the work of big-name visual artists is traded for millions, and the writers and directors attached to box-office success and best-seller lists are invited onto Oprah's TV show and fawned over by lesser oracles.

Virtually every other artist is regarded as a member of a highly dispensable group: people who expect the world to reward them for playing, those who are understood to contribute nothing to what is seen as the serious work of society. As with most stereotypes, this one contains opposites: artists are often seen as effete and elitist, looking down on ordinary mortals; or as primitives, driven by intense emotions and creative forces, heedless of convention or consequences.

Distinctions depend on contrasts, and the key contrast here is with corporations, the social sector widely seen as most tightly focused on markets, the apex of all that is deemed concrete and productive. When value is judged by income or market volume and scope, most artists' work fades into insignificance. What can't be captured using that scale of value is capacity for reflection—especially critical or propositional reflection—of the type that James Baldwin described when he asserted, as I have quoted in "Hidden in Plain Sight," that "The purpose of art is to lay bare the questions which have been hidden by the answers."

For me, three questions always bear repeating:

Who are we as a people?

What do we stand for?

How do we want to be remembered?

Answers are numberless, but in this moment, our clearest choice is between two, the answer that can be discerned from our deeds rather than our words; and the answer that embodies our potential for moral grandeur.

Either we are consumers who stand for the multiplication of market-choices and will be remembered for exhausting civilization and the planet that houses it in an orgy of acquisition and exploitation. Or we are multidimensional human beings aware of our own capacity for help and harm and who stand for pluralism, participation and equity, for justice tempered by love; and we want to be remembered for our vast creativity in service of The Golden Rule.

To actualize the first answer, do nothing. To explore the second, read on.

When I address audiences of artists and advocates, I often think of a scene in the Woody Allen movie *Annie Hall*. Allen plays a version of himself, a neurotic, libidinous writer-comedian who desires and mistrusts absolutely everything. In a moment of self-reflection, he imagines returning to his elementary school classroom. One by one, the sweet-faced students rise and in piping voices, declare their future fates. One is a dress manufacturer, another runs a plumbing company, a third is a former heroin addict now addicted to methadone. It's not that their futures are terrible—most aren't—it's just the poignancy of seeing so much pint-sized potential reduced to compromises and resignations.

Many of those in the audiences for my talks have spent a lifetime trying to make their case to keepers of the gates to social power, influence,

and resources. Like the children in Allen's film, each of us has our adult persona, the face we present to the world. But beneath that, it is often possible to discern a glimpse of who we really are, the essence we brought into the world as children and—somehow, somewhere—retain all our lives. These audience members might call themselves writers and musicians and painters, or artistic directors and development directors and general managers, professors or deans or dozens of other titles. But if all were to stand in turn to describe whatever lit the spark that has fueled their lives, every one would have a profound story to tell, and there would often be similarities in those stories transcending countless differences in circumstance and identity.

Some will have been blessed with the kind of environment every child deserves, surrounded by loving family and friends who support the process of becoming fully oneself, a fully creative being. More will have come to consciousness in a little world of family or community incapable of truly meeting and receiving them. Like myself, many of those who share this experience will later say their lives were saved by art, by discovering in their own imaginations and capabilities a refuge that no external threat could destroy.

Consider my own experience. I grew up in a socially and economically marginal family, in a house without books, without music, without objects or images other than family photographs and mementos. Our home was crammed with generations of immigrants and their offspring. The adults had a limited understanding of conventional social mores, and a limited desire to abide by those they did understand. I saw and heard things that seldom leak through the shield that protects many children. Despite being closely observed and having little privacy, I often felt I was on my own, and to a significant extent I was. By a stroke of good fortune, from an early age, I demonstrated a flair for line and color, an ability to capture a likeness. By the time I entered school, the world of art had become my sanctuary.

If I complained of a sore throat, I got to stay home from school and draw, so I complained often. In school there were art teachers, and by the time I was in high school, they let me slip into empty classrooms to paint or draw, the only hour of each day I had a quiet place to myself. I used my pencils and paints to create the universe I wished to inhabit. Bizarrely, the artist I most identified with was the damaged aristocrat Henri de Toulouse-Lautrec, whose ambivalent depictions of Montmartre nightlife seemed inexplicably familiar and beautiful. I think it was because he embodied a trait nearly universal in artists: a natural proclivity to make something beautiful or engaging or otherwise meaningful from one's alienation.

Becoming an artist gave me empathy, imagination, the ability to conceive of another life, the skills of observation, reflection, and communication, the experience of beauty, the power to create meaning, a taste of what it meant to excel at something, the desire to always go deeper and see more, and a longing to use my gifts to make a difference. Most of all, it gave me a dual identity as observer and participant that equipped me for every role I have since occupied, first as painter, graphic designer, and community organizer, then as writer, speaker, social activist, and consultant.

Even though I live in northern California and made the long march through the counterculture of the sixties, I'm not an especially credulous person. But like many in my generation, I have at times been prepared to sample alternate realities rather than resign myself to the claim that none exist. When a psychic once told me that I came here from another planet where problems like greed and prejudice had been solved, I listened. She said that this explains my persistent astonishment at how far from solved these problems are here on Planet Earth. I never took her pronouncement literally: the likelihood is strong that the much more prosaic birth-story I was told is true through and through (and I have the birth certificate to prove it). Instead, I heard the psychic's words as

a powerful metaphor for something that I share with many artists: a profound conviction that much of what is considered normal is in fact deeply distorted—that conventional wisdom functions less as a useful guide to reality than a smokescreen for it. Often, the budding artist feels somehow outside the ordinary reality he or she inhabits; there's an awareness of the arbitrariness of social consensus, of the possibility that things might be different and of the imagination to see how.

Of course, I'm by no means the only alien I know. Indeed, in our society, experience of alienation is widely distributed and certainly not limited to artists. Countless people are made to feel other on account of perceived differences: skin color, ethnic heritage, immigration status, sexual orientation, religion, social status, physical ability, growing up in an operatically dysfunctional family, and on and on. But among all the aliens, artists have the power to open a portal of imagination and empathy that anyone can enter. Whatever is found there—pleasure, healing, sadness, awakening, incitement, horror, wonder—enlarges awareness, and that expands possibility. Ironically, artists' capacity to invite and include is very often fueled by their otherness: no alienation, no compassion; no compassion, no connection.

Regardless of our individual stories, behind the choice to live one's life in the arts, as a maker of beauty and meaning or one who supports that process, there is always an awakening that can best be characterized in spiritual terms, as an encounter with the ineffable, with something that can never be adequately expressed but which ignites in our hearts the desire to keep trying. The specifics of these encounters vary. One artist might have been taken for the first time to a theater, a film, or a concert, finding herself transported in that darkened space to a time and place markedly different from ordinary life, where her entire being was concentrated on receiving something: body, feelings, mind, and spirit

coming for the first time into absolute, coherent focus. Another artist might have lifted his own voice in song or raised a charged brush to make a mark on paper, and in the moment of creation felt himself at the center of time standing still, completely awake and completely dissolved in the experience. As people tell these tales, when the lights came up—when the song ended, when the drawing was finished—something new had begun to emerge. Even if they didn't understand what it was, they knew they wanted to return to it as soon and as often as possible. The stories are all different, and they are all the same.

I often quote the English writer Walter Pater, because his words hint at this awakening moment in a way that seems very true: "All art constantly aspires towards the condition of music," he wrote, "because, in its ideal, consummate moments, the end is not distinct from the means, the form from the matter, the subject from the expression." Pater was writing about art in the narrow sense, works created with the awareness and intention associated in the last few centuries of western thought with high art, and of course music in particular. But I think he was also describing an integrated state of being that most often arises from an encounter with the sublime. It is the way we feel in the full flow of creativity, when overcome by love, when gazing into the heart of a rose, when standing at the edge of the Grand Canyon or the Pacific Ocean, bathed in setting sunlight. It is one of the essential experiences of being human, and it is the core of identity and meaning from which many artists' commitment evolves.

Such experiences teach us what it is to be fully alive and awake. Indeed, these experiences of integration, of wholeness, recall the most potent of relationships, love. Plato saw Eros as the attraction to what is beautiful, good, and true in all things. In precisely that sense, art can eroticize experience. Human beings in love desire the well-being of the beloved, want to know the beloved as deeply and fully as possible. Just so, a profound experience of art can open us to compassion and

presence. Indeed, an impulse shared by many of the artists who create such opportunities is to awaken fully, both themselves and others.

Making art is not the only route to this experience, but it is a most direct one. The plain truth is that for many people, including those who might say, "I don't know anything about art," cultural practice—images, stories, music, dancing, taking part in rituals and celebrations—is the essential stuff of life and the principal container of meaning. Music lightens their way as they go from place to place; they dance to celebrate life's milestones; they sing to honor whatever they hold sacred. They make a personal sanctuary of the rooms they inhabit, adorning them with the images that symbolize their delight and desire. Stories on film, television, and the printed page, new stories and stories passed mouth to ear for generations, spur passionate and thoughtful conversations about the great questions of the day.

This ecology sustains professional artists exactly as the entire forest floor sustains *Sequoia sempervirens*. But even some "arts people" don't see it.

That's because "the arts" as a concept has been jammed into a frame that is all about entitlement and privilege, a frame that changes the focus from beauty and meaning to money and power. Henry Lee Higginson founded the USA's first symphony orchestra in Boston by exhorting his fellow plutocrats to "Educate, and save ourselves and our families and our money from the mobs!" The stink of that has clung for 125 years. The snobbery contaminating much of the nonprofit arts sector has obscured art's public purpose and alienated potential supporters.

Much of this is embedded in the phrase "the arts." It's abstract, one step removed from things people really care about: many people who happily embrace words like *music* or *movies*, who sing or draw or love to dance, will respond negatively to the idea of "the arts"—*Oh no, not*

me, you hear them say, *I'm not into the arts.* Ask that same person, "Do you like to dance?" or "Do you play an instrument?" and the answer will be "Yes," with no evident awareness of contradiction.

That's because when they hear "the arts," they pick up on the phrase's exclusionary subtext. Many people who consider themselves part of "the arts" use that label to distinguish the work of their subsidized organizations from commercial cultural industries and entertainments or from the pastimes of people they consider hobbyists. An enormous industry generates multibillions each year from sales of music, movie tickets, video rentals, concert tickets, and the like; and untold numbers take pleasure in making music, taking photographs, writing poems and songs, participating in dance competitions and poetry slams, and so on. Yet, except when they want to summon impressive statistics on the scope of the cultural economy, mainstream arts advocates seldom include all of this. Their default presumes the superiority of nonprofit arts organizations and the work they present, expressing a kneejerk dismissal of the rest.

Consequently, this discourse often has an air of unreality: I hear advocates saying that "the arts" are in decline, yet—to pick just one example—almost everyone I encounter integrates music into daily life almost as a kind of remedy, self-prescribing the sounds and feelings that will support them through the day.

The wide gap that often opens between the world as seen from inside "the arts" frame and the world most people live in is hard to bridge. My favorite story about this unfolded several decades ago at a conference presentation by the president of a major symphony orchestra. Full of enthusiasm, she described the orchestra's in-school programs: small ensembles and individual musicians visited classrooms to demonstrate their instruments or play and explain bits of recorded music. "And some of these children," she concluded, "have never heard music before!"

In 2008, Americans for The Arts, a national arts advocacy organization, offered a series of public service announcements that promote canonical artists—Brahms, Van Gogh, Elizabeth Barrett Browning, Tchaikovsky—as if they were breakfast foods. The one I've seen most often, *Raisin Brahms*,[59] is remarkable for its evident lack of awareness. An African American family sits at breakfast. (Since the starring artists are white, any nod in the direction of diversity must come from their admirers.) A white-bearded Johannes Brahms bursts through the wall riding a grand piano while touting his cereal fortified with "increased test scores and creative problem-solving." Round-eyed and amazed, the two kids sprout their own long, silky, white beards. The tagline? "Feed your kids the arts."

Would you like a side of subtext with that?

The unconscious character of this encoded snobbery does nothing to soften its effects. People know when they are being condescended to; few choose to volunteer for the experience. Taste is taste, not objective reality or ultimate virtue. Personal taste is an artifact of social grouping as much as are individual choices: mostly, people like what their friends like, or what is liked by those they admire or desire, or what places them in the same category as those whose status they covet. Yet the world that calls itself "the arts" has generated endless justifications for the moral and aesthetic superiority of certain preferences. The resulting invidious snobbery attaching to "the arts" goes a long way to explain why people don't come out in droves to lobby for arts funding. It isn't a new phenomenon, either, as Henry Lee Higginson's words demonstrate.

In North America, even public discussion about cultural policy has been constrained by this snobbery. Instead of raising essential cultural questions—digital democracy, cultural equity, the nature of education, the public interest in telecommunications, the role of artists in building community and economic recovery—the whole debate has been reduced

59 It can be seen on YouTube: http://youtu.be/kKgBdrsqvjs

to an on-off switch: public agency grants to artists and organizations, yes or no? Instead of a great case for a great cause, arts advocacy often sounds like special pleading by the beneficiaries for their own incomes. There's nothing wrong with a decent living for valuable work, but framed that way, advocacy doesn't win many allies.

In business, a "value proposition" states the unique value of whatever you are offering, derived from identifying the costs and the benefits to your particular market, the distinguishing character of your product or service, and the evidence that supports your conclusions.

Recently, the language of "the value proposition" has begun to creep into arts advocates' vocabulary. Every time I hear the phrase, a little scene from an old movie pops into my head: in a dark alley, a bandit pokes a gun into his victim's back and offers a choice: "Your money or your life." A different type of value proposition, admittedly, but one that is worthy of what is actually at stake. One that encapsulates our real choice: I fear for our future if we continue disinvesting in the best ways we humans know of cultivating a life worth living, if we continue privileging profit over people. I fear for our future if we continue to muster only weak arguments and special pleading for art's public purpose, minimizing the real value of culture in the service of democracy and freedom.

Mostly, the question of art's public purpose is not being put in the straightforward terms it warrants. Instead, such debate as exists is primarily about spin, cover-story, and framing—using imagery, emotion, and symbolic language to alter the meanings attaching to a potent concept.

Framing is easy to see in conventional political discourse. For example, right-wing politicians in the U.S. were able to contaminate the idea of a tax on inherited wealth by reframing it as the "death tax." But word-choice is just one concrete expression of an underlying frame, a

deep and deeply influential meta-story. Everybody likes to use the word "freedom," for instance, because it is by now so encrusted with intense positive feelings and associations that its effect is akin to spraying the room with pine-and-sunshine–scented cologne. In the U.S., if you can successfully associate your own issue with the Our Cherished Freedoms frame (instead of the dreaded "Government Control" frame), you are one happy campaigner.

A core frame in our economic discourse might be called "The American Dream," which brings to mind individuals working hard and being rewarded with home ownership, personal safety, friendly neighbors, and fragrant backyard barbecues. In the American Dream frame, the public issues/private troubles conversion has been fulfilled: economic failure is punishment for a lack of industry or prudence. Evoking this frame has been a boon to corporate depredation. For example, countless urban neighborhoods have been wiped out by developers lured with tax-breaks and subsidies billed as the route to prosperity for all in shiny new homes, with American Dream imagery masking removal of the former residents who don't fit the frame. An alternative, truth-based frame would portray public agencies and developers colluding to profit at low-income residents' expense. Exposing the true costs of these policies could lead to proposing a system that really does reward the hard work of families already living in neighborhoods slated for corporate makeovers.

In 2009, I addressed an audience of arts advocates in Vancouver, British Columbia, where massive cuts in public cultural expenditure had just been announced, cuts amounting to more than 90% over three years. An incident that had taken place the previous September was seen as particularly telling: in a campaign speech, Prime Minister Stephen Harper said, "I think when ordinary working people come home, turn on the TV and see a gala of a bunch of people at, you know, a rich gala all subsidized by taxpayers claiming their subsidies aren't high

enough, when they know those subsidies have actually gone up—I'm not sure that's something that resonates with ordinary people."[60] The outraged response from high-profile artists, who condemned Harper for conflating all publicly supported art with a red-carpet gala, was widely seen as cutting into Harper's result in the election (although not nearly enough to unseat him).

Harper's remark resonated with a core frame in public perception of artists: the idea of artists playing around—purporting to work when they are actually partying—at the expense of taxpayers who don't have nearly so much fun on the job. This frame comes with all sorts of embellishments: artists thumb their noses at convention, thrusting shocking subjects into the public eye; they make spectacles of themselves, behaving like children; and so on. This puts arts subsidy on the highly dispensable list, a frill that is easy to trim when times are hard. It invites the type of comparison that—while seldom stated outright—underpins arts-subvention debates: do you really want to support a bunch of flaky, outspoken, hard-partying hippies and elitists when the money could go to medical care or housing the homeless or buying school lunches?

Ostensibly, the debate is all about dollars-and-cents: compared to other public purposes, is cultural subsidy a good expenditure of funds? But that's only on the surface. We know it isn't about money per se, because the sums entailed are so tiny that they have accurately been compared to a rounding error in larger public-sector budget items such as healthcare and defense. When I spoke there, the total public arts allocation for British Columbia represented only one-twentieth of one percent of the provincial budget, a nickel out of every $100.

Here in the U.S., at the beginning of 2011, Kansas' Republican governor Sam Brownback said he was eliminating the Kansas Arts

60 "Ordinary folks don't care about arts: Harper," *Toronto Star*, 24 September 2008. http://www.thestar.com/federal%20election/article/504811--ordinary-folks-don-t-care-about-arts-harper

Commission, that state's public arts agency. Brownback framed his decision as an economic choice: "Our state faces a nearly $500 million budget shortfall," he said. "Let's do all we can to protect the core functions of government." But the agency received $778,200 in direct funding from the National Endowment for the Arts (NEA) and $437,767 in indirect grants and services from the Mid-America Arts Alliance, a regional funder, so the net effect would be a loss of several hundred thousand dollars coming into the state from outside sources.

At the same time, House Republicans proposed reducing the allocations for both the NEA and the National Endowment for the Humanities (NEH) to zero. That involved two separate agencies budgeted at $167.5 million apiece, for a total cost savings of $335 million. The savings would have equaled less than one-thousandth of a percent of the cost of just the war in Afghanistan since 2001, and less than one-millionth of a percent of the total FY 2011 federal budget. It's less than one-twentieth of the FY 2011 budget for nuclear weapons, still being stockpiled at great cost to taxpayers "just in case." The agencies weren't actually zeroed out—although that will be threatened again, no doubt—but they were cut to a combined budget the equivalent of about a dollar a year per capita, an investment in the public interest in art equal to half the cost of a plain Starbuck's coffee, less than half the cost of a New York subway ride.

At the end of 2010, President Obama pressed for and won a two-year extension of Bush-era tax cuts. The $858 billion tax deal included:

- $61 billion in income tax cuts for the wealthiest;
- a cap on taxation of capital gains and dividends at a cost of $54 billion;
- raising the ceiling on high-income tax deductions at a cost of $21 billion;
- dropping estate taxes to 35 percent after a $5 million individual exemption, at a cost of $68 billion; and

- an investment write-off for capital-intensive businesses, at a cost of $21 billion.

The bill had other provisions, such as an unemployment benefits extension. But totaling the provisions exclusively targeted at helping the wealthy yielded $225 billion in lost revenues. This is equivalent to the daily expenditure of twice the combined annual NEA/NEH budgets, seven days a week, for the two years covered by the bill.

These examples are essentially arbitrary. I could just as well have chosen to highlight any other year and found abundant illustrations of the same political math: Potemkin Village rhetoric that uses cuts in cultural allocations to cover free spending that benefits powerful special interests at everyone else's expense.

In truth, when politicians decide to decapitate arts funding, they aren't even trying to make a significant economic impact. Instead, they are using budget cuts as a form of political speech, cutting something that most voters don't perceive as directly affecting them, let alone as creating widespread pain. In terms of political impact, it's a bargain: while the dollars involved are few, the cuts garner plenty of publicity, since artists and their advocates are very good at communicating their displeasure. In essence, politicians use arts advocates as a megaphone to issue a political message: *Look at the criticism I'm willing to take to save voters money! I lopped the head off all this unnecessary crap like art before even trimming the fat from the things you really care about!*

In this political maneuver, money is the sizzle, not the steak.

When the NEA was threatened with extinction in 2011, like thousands of others I went to the website of Americans for the Arts (the biggest national arts advocacy group) to send a message to my elected representatives. There I found three readymade talking points that could be added with one click: two were about money (the scope

of the arts industry, the assertion that public funding leverages private money), and the third pointed out that NEA funding goes to every state, reminding legislators that every one of them has a dog in the race. These arguments are so bloodless and soporific that I can't imagine anyone actually reading all the way to the end of an op-ed based on them. The site had nothing to say about what was really happening—how arts funding was being used by politicians to send a message, and why.

Arts funding is politically useful as a rhetorical device precisely because the anti-artist frame is already resident in many people's minds. Politicians don't have to argue affirmatively why they find arts subvention so dispensable. If speaking their views aloud triggers much opposition (as happened with Stephen Harper in Canada) they can play off the embedded frame without saying a word. And here's the real rub: when arts advocates allow politicians to set the frame this way—when artists obligingly respond to politicians' cover-story about belt-tightening as if it were the whole and true story, when they obediently focus primarily on dollars-and-cents arguments—they don't disrupt the underlying frame at all. So long as that continues, regardless of how solidly the economic counter-arguments are made, every time budget cuts are contemplated, arts funding will once again top the list of candidates for the guillotine.

I'm not pointing to a moral or ethical failure of individual elected officials (although surely that comes into it sometimes). All politics involves horse-trading, which is why the marketplace is a wonderful metaphor for the give-and-take central to any political process: you need something, I can supply it, you reward me, and if we are fair traders, we will both be around to do it again when the tables are turned.

But the big problem with our wounded democracy is that the market is no longer just a metaphor. Today, it's a straightforward description of the buying and selling of public policy. For the 2012 election, Presidential candidates attempted to raise in the neighborhood of a billion dollars in

campaign contributions; that required focusing their primary energies on the desires of the rich, plain and simple.

Most politicians start a career with some vision, some ideals. But the dominion of political money and its temptations is powerfully seductive: access to the mighty titans of commerce and the air of luxury they breathe, the opportunity to dole out favors and extract the promise of favors in return, the dangled hope of reward that comes from believing your own propaganda. It pervades and poisons the entire body politic. In recent years, activists have begun to fight back: as I write, there is a growing movement to abolish corporate personhood, in effect undercutting the Supreme Court's 2010 Citizens United decision defining corporate and union campaign contributions as protected speech. But money's death-grip on American politics is strong and unlikely to release unless forced to do so by an upwelling of sentiment strong enough to impel Congress to act.

In this atmosphere, it is no wonder that so many arts advocates believe that market ideas and economic arguments are the only ones worth putting forward. It is easy to see how they might fall into the error of believing that the officials who are squandering democracy on sustaining the privileges of the wealthiest and most powerful could only be reached by arguing that arts activities grow the economy, that they produce wealth. But those officials aren't promoting the agenda of corporate and financial elites out of the considered, disinterested conviction that it will be best for the United States. They are promoting it because they have been paid—in money, influence, flattery, the promise of more power—to do so. Sometimes, without even noticing it, they have come to see the interests of those who pay the piper as their own. Once that process of internalization is complete, dancing to the same tune just seems natural.

Advocates for public cultural investment cannot compete successfully in this money-driven political marketplace because they

do not possess the vast economic power required. A campaign that consists of repeatedly inundating officials with assertions of art's economic impact is not going to change that. The few elected officials who can be persuaded to act as forthright advocates will be those from safe, cosmopolitan districts; the rest will not jeopardize their seats by speaking out on an issue they do not see as critical to their support. The one possible path is mobilizing significant numbers to act, radically changing the way we and our fellow citizens see the public interest in art.

This wouldn't be as hard as it sounds. The sad and ironic reality is that even the minds of those charged with advocating for the public interest in art have been so fully colonized by Corporation Nation, they seldom trouble to point out just what our tax funds are buying instead of social goods like culture, education, and healthcare. The most powerful arguments haven't yet been made.

The whole debate is predicated on a fiction that is treated as reality: that every public expenditure must measure up to the same standards. In conventional political discourse, we are told that all social goods must prove themselves worthy of support by government, foundations, and donors, and that arts funding keeps getting cut because advocates just haven't made the case. Every time a federal budget is proposed, the NEA's minuscule allocation is subjected to microscopic scrutiny, which usually results in shaving a little off the top of a budget that is already nearly bald.

In truth, the burden of proof usually falls in inverse proportion to the amount of resources at stake and the power of those whose interests are involved. In 2011, I was commissioned to write an essay[61] as part of a study on art's "intrinsic impact." I chose to write it in the form of a conversation modeled on Plato's *Symposium*. The character called "Teacher" deconstructs this argument, responding to a statement by

61 Arlene Goldbard, "Symposium: Seven Characters in Search of An Audience (with apologies to Plato)," in *Counting New Beans: Intrinsic Impact and The Value of Art,* Theatre Bay Area, 2012.

"Exec," a retired marketing executive who sits on the board of a major African American theater company. When Exec's turn comes, he tells the two previous speakers—a playwright and a sort of critic-scholar—that they are full of it. Their faces show shock.

"You heard me right," Exec says. "And I am speaking from the perspective of someone who is living right here on planet earth, not in the artworld. I was in business for over forty years before I retired. Do you know what I learned? Lesson number one? If people don't want something, you can't make them pay for it."

Later on, then, Teacher questions his statement:

"But that is not true. Do you think if we took a referendum on how much voters want to spend on missile guidance systems, the Department of Defense budget would remain intact? Taxpayers are paying for all kinds of things they would not want to pay for if given a choice. Some of those things are what are called social goods, which, ideally we should all want for the common good. But the common good is not a very common goal right now, I think. Look at all the people who complain about paying for public education, simply because they do not have children in the schools.

"Most societies deal with that by requiring people to pay their taxes and giving elected officials the right to say where those taxes should go. But there are many things like that in the private sector too. We pay inflated prices for some things to cover the cost of advertising or research: look at the difference between what we pay for certain medications and what they cost in other countries. What we pay for fuel makes oil companies rich, but the only choice we are given is pay up or give up driving, so we pay. Even many of the products that supposedly represent the triumph of free markets get a boost from public policy. Look at corn, for instance, all the money that is spent

growing corn nobody needs. There is a name for this, is there not? Corporate welfare.

"So it is not correct to portray things the way some people do: over here is the free market where everything is given its just value, and over there is the unfair system where people expect to be paid for doing nothing. What I see is, over here is the part of the system where people successfully lobby for advantage, and over there is the part where they don't have the money or the power to do that. Isn't that more accurate?

"A couple of the kids in a play I directed this year did a unit in social studies on how the arts are funded. One of them came into rehearsal with a statistic that made everyone loco: every single day, seven days a week, we are spending much more than two annual National Endowment for the Arts budgets on war. They had other figures comparing the prison budget with arts spending, things like that. Do you really think that this balance of expenditures reflects public choice? I am not able to offer proof, because I am not aware of polls on that precise question. But my kids would not have supported that notion of the public good. They were appalled by it. I am saying all this because I would like this conversation to be based on reality, and not the myth that the arts are the big welfare cheaters while the free market rules the day for everyone else. That just is not true.

"Remember what I said about teaching the controversy? I think it would be great to have a national conversation where we clear away the myths and look at what is left. Which things that do not earn their keep do we want to pay for? I would like to have a say in that. Personally, I would choose theater and other such things—music and art and education and medical care and so on—over subsidies for agribusiness, banks, and oil companies. I have an idea that a majority of voters would

agree. But even if that is wrong, if the outcome of the debate was based on letting the hot air out of all sides of the issue and giving our values a fair chance to contend, I think I would accept it. It would be a big relief to stop having those debates that ring so false, where we fling assertions at each other without fully believing them."

So far, the questions that should animate public policy and funding are never asked, and officials are never held accountable for their answers:

Who are we as a people?

What do we stand for?

What do we want to be known for: our stupendous ability to punish, or our vast creativity?

But that can change.

The anti-artist frame interlocks perfectly with a widespread taboo on certain types of free expression, especially views critical of entrenched wealth and power. On the face of it, Americans have freedom of speech; other than "Fire!" in a crowded theater, we are free to say what we choose. But if we criticize the privileged, as many more of us are prone to do since the dawn of the Occupy movement, we expect to be charged with fomenting class warfare, and we are certain to encounter many people whose material circumstances in no way resemble the super-rich rising to defend them on grounds of fairness.

To a certain extent, this defense is an inherited trait: during the late 1940s-early 1950s McCarthy era, when communists, socialists, and liberals were vilified and condemned as un-American, the invocation of "class warfare" was sufficient to ignite terror. Transmitted from generation to generation, the echo of that fear persists even for people who were born much later.

But it is also rooted in empathy: *It's not fair*, people think. *If I were to become rich, that wouldn't make me a bad person.* This amounts to a widespread and damaging category error: it's true that all individuals, regardless of social status, have equal potential to live ethical lives, to act with compassion and fairness. Being rich isn't an automatic disqualifier any more than being poor. Neither do certain individuals' high ethical standards obviate the many ways the deck is stacked on behalf of powerful groups or ameliorate the damage done by policies that privilege their class.

This prohibition on critical speech is subtle and pervasive, but the net result is this: that among all elements of public policy in the U.S., censorship is the most thoroughly decentralized. There is little need for the heavy hand of the censor when so many people—having inherited a case of fear of free expression and its consequences—will obligingly censor themselves. The particulars change over time. Back in the late seventies, when I was involved in community organizing with artists, I was more than once told to avoid the word "democracy." *It's kind of controversial, isn't it?* Today, "capitalism" is a trigger-word, one the right has substantially succeeded in replacing with "free enterprise." Whatever the contested words, in some circles, to say that a viewpoint is controversial is still tantamount to saying it ought not to be expressed. How did this come to be?

When I look back at U.S. cultural history, I see a chain of inoculations against free expression. Whether you start 60 years ago with the McCarthy era or wind the clock back 300 years to the Salem witch trials, you will see it too. From time to time, censors sound an alarm, promising punishment to those whose expressions they find offensive. In Senator Joseph McCarthy's Red Scare, Hollywood was a main target, but many other artists, writers, and academics suffered loss of livelihood or freedom. Some were forced into exile. In the "culture wars" of the 1980s and 90s, Hollywood shared the limelight, but starring roles went

to a handful of avant-garde artists who'd received tiny grants from the National Endowment for the Arts.

For inoculation purposes, the particular targets don't much matter: whatever's handy, so long as it will attract attention. Motives are always mixed. Such campaigns are driven as much by desire for economic or political power as by the wish to purify culture of elements that undermine established authority, questioning sexual, religious, or political orthodoxies. What matters is that a clear message go forth that it is dangerous to express certain ideas, that a fresh blast of fear should be felt in the land.

Each successive campaign has thus been smaller in scale than the last: with a massive early inoculation, each booster-shot requires a smaller dose to remind people to watch their step. Estimates of the 15th to 17th-century witch-hunts in Europe and North America put the death toll at 60,000 (at a time when global population was estimated at 500 million; the equivalent today would be three-quarters of a million put to death). In the McCarthy era, hundreds were imprisoned, and it is estimated that 10-12,000 lost jobs. In the 1980s-1990s culture wars, the inoculation was accomplished with only a handful of scapegoats.

In 1989, the extreme right, led by The American Family Association (AFA), launched a direct-mail attack on the National Endowment for the Arts for funding works ideologues found blasphemous or obscene, especially work by visual artists Andres Serrano, Robert Mapplethorpe, and filmmaker Marlon Riggs. The following year, then-NEA Chair John Frohnmayer vetoed grants for four performance artists who had been similarly criticized; as "The NEA Four," they later won a much-publicized court case restoring their funds.

This was all symbolic combat, of course: AFA founder Reverend Donald Wildmon gave Serrano's, Mapplethorpe's, and Riggs' work far wider distribution at his own organization's expense (and in aid of his own organization's fundraising) than it ever would have

received otherwise. Wildmon started the AFA in 1977 as the National Federation for Decency, focusing on Hollywood and asserting that objectionable films, recordings, and television were produced by Jews to undermine Christian values. It wasn't until he jumped on the arts funding bandwagon—inflating a tiny amount of public funding for a few projects into a full-scale moral panic—that his enterprise took off. His genius was to recognize the fundraising value of a shocking image, and to take it all the way to the bank.

The extreme-right pundit Pat Buchanan's address to the 1992 Republican National Convention is often dubbed his "culture wars" speech. Even though the speech didn't employ that exact phrase, Buchanan exhorted the assembled in explicitly cultural terms: "[W]e must take back our cities, and take back our culture, and take back our country," asserting "the right of small towns and communities to control the raw sewage of pornography that pollutes our popular culture."

Buchanan spelled out the point of contention pretty clearly: to whom does this nation belong? To all its people, or only those who, like Buchanan, emanate a sense of ownership that attaches to being white and right-wing? Whose ideas, expressions, identities are entitled to public space and equal dignity? All of us, or only those who conform to the values enshrined by censors?

These questions aren't going away. But I really dislike thinking about how minuscule the next dose of overt censorship has to be to accomplish its booster inoculation.

We carry these experiences within our own memory and consciousness. As I write these words, I feel the class-warfare frame arise in my own mind. I have no doubt that the commercialization of absolutely everything is a common thread in all of our wicked problems and social messes: if no one profited from dirty energy, for instance, public investment in clean energy would already have made significant inroads into climate change. If special pleading by lobbyists and donors

hadn't influenced politicians to create so many opportunities to privatize public goods, unemployment and deteriorating infrastructure would not be such epidemic challenges; and so on. The prohibition against pointing these things out—or to be more specific, against naming the beneficiaries and culprits and showing how much of the expense of their self-serving actions is borne by the rest of us—is powerful. Some people may stop reading what I have written on account of the discomfort this triggers.

What's required to see things clearly in the face of such prohibitions is refusal to accept the inoculation. This entails ruthless self-examination. What have you been reluctant to express for fear of disapproval? How often do you perform a mental calculation, ending with the bottom line that it's not worth the risk to represent your own truths fully and forthrightly? Or not worth the hassle of defending others who do, even when opponents try to silence them? None of us is completely immune to self-censorship. But it can help to strengthen resistance to look at the remarkable extent to which a little bit of overt censorship can now go a very long way in suppressing freedom of expression. It can help to assert a refusal to go along, and to back it up with both speech and deeds. It can help to notice the discomfort that can arise when the prohibition is transgressed, and continue anyway.

None of this is explicitly acknowledged in Corporation Nation, a world that (*pace* Oscar Wilde) knows the price of everything and the value of nothing. Of course, not all corporations are alike: there are businesses that express social responsibility through green technology, charitable giving, or fair trade practices, just as there are businesses that pollute, demand wage and benefit cuts while increasing executive bonuses, or export factories and jobs to low-wage markets, displacing thousands. When I write "Corporation Nation," I am characterizing the

negative impacts of those businesses and lobbies—multinational energy corporations, Big Pharma, the U.S. Chamber of Commerce, and their ilk—that pursue power and advantage at public expense.

Only two letters are need to symbolize the worst of these excesses: BP. On April 20, 2010, an explosion on a rig drilling a new well for BP led to the largest oil spill in American history. Three top executives— Chief Executive Tony Hayward, Chairman Carl-Henric Svanberg, and Managing Director Robert Dudley (the "Burghers of BP" in part 26 of "Hidden in Plain Sight")—were called upon to explain and respond to questions from the press, the public, Congress, and the President. In mid-May, Hayward publicly minimized the size of the spill, saying, "I think the environmental impact of this disaster is likely to be very, very modest." Two weeks later, he said, "There's no one who wants this thing over more than I do. You know, I'd like my life back." In mid-June of that year, emerging from a lengthy meeting with President Obama, Svanberg concluded his response to reporters' questions by saying, "We care about the small people. I hear comments sometimes that large oil companies are greedy companies that don't care, but that is not the case at BP. We care about the small people." A couple of days later, Hayward took a day off from the disaster to see the vessel he co-owns compete in yacht races.

Each of these actions provoked outrage. I heard them dismissed as Euro-snobbery, or the sort of elite out-of-touch-ness that made people back in 1998 believe that then-President George H.W. Bush's evident fascination with a supermarket scanner demonstration meant that he'd never before seen groceries checked out. But unlike the patrician Bush, these three executives rose through corporate ranks from unremarkable beginnings. Hayward studied geology, starting at BP nearly 30 years earlier as a rig geologist in Scotland. Svanberg studied applied physics and business administration, working his way up to CEO of the Swedish telecom company Ericsson before joining BP. Dudley studied chemical engineering and management, working for Amoco until it was acquired

by BP. These are company men, and the distortions in their response to the damage they'd done reflect the distortions of their corporate culture.

At the end of that July, *The New York Times*[62] carried an op-ed by David Stockman, Reagan-era Director of the Office of Management and Budget. For people who followed national politics in the early 1980s, Stockman's name evokes the phrase "trickle-down theory." Although his own views have moderated in the decades since, I can't help but see Stockman as a symbol of entrenched privilege, an author of policies that promoted private profit at the expense of the public good. Yet Stockman's op-ed excoriated Republicans for prioritizing tax breaks for the wealthy above economic health and well-being, blaming them for "the serial financial bubbles and Wall Street depredations that have crippled our economy." The next day, a column by economist Paul Krugman— Stockman's ideological opposite—agreed "that our governing elite just doesn't care—that a once-unthinkable level of economic distress is in the process of becoming the new normal."[63] The point, Krugman wrote, "is that a large part of Congress—large enough to block any action on jobs—cares a lot about taxes on the richest 1 percent of the population, but very little about the plight of Americans who can't find work."

Something is very wrong in Corporation Nation, where virtues like social responsibility, altruism, and compassion most often appear as advertising ploys, cynical jokes, or acts of contrition. Something is so wrong that even some conservatives have broken ranks to say so.

Tony Hayward has a knack for embodying the problem. In a July 2009 YouTube video,[64] he cheerfully describes to a Stanford University Graduate School of Business audience the corporate self-assessment he launched for BP. He concludes that "We had too many people that were

62 David Stockman, "Four Deformations of The Apocalypse," *The New York Times*, July 31, 2010.

63 Paul Krugman, "Defining Prosperity Down," *The New York Times*, August 1, 2010.

64 http://www.youtube.com/watch?v=3b6J7LRUTFY (now redacted)

working to save the world. We'd sort of lost track of the fact that our primary purpose is to create value for our shareholders. How you do that, you have to take care of the world. But our primary purpose in life was not to save the world." The clip is worth watching to contemplate the dichotomy Hayward proposes (is the choice really between creating value for investors and saving the world?); and to comprehend Hayward's delight at sharing this observation, his evident obliviousness to how his proposition might sound if the future didn't go his way.

This disconnect is by no means unique to BP. Neither is the problem intrinsic to enterprise itself. Much like families and tribes, markets are a foundational element of all human society. The people of the coast trade fish for berries picked by the people of the valley. Over time, secondary trades evolve, eventually aggregating into vast networks, such as the 4,000-mile Silk Route that joined Asia with Europe. Fast-forward a millennium or two: commerce is the chief use we now make of the new technologies that have dissolved distance between coastlines and valleys half a world apart. Not only has the internet become a mammoth shopping mall, with businesses of every type and scale marketing goods and services to consumers, but sites like eBay and Craigslist have turned millions of ordinary people into small-scale entrepreneurs, recycling their old furniture and clothes for cash. Just as fish gotta swim and birds gotta fly, humans gotta buy, sell, and barter.

The problem is, some of us don't know when to stop, and they are contaminating our culture with unbridled, heedless appetite. Certain names ring out: the Koch brothers, David and Charles, have become central villains in the critique of Tea Party politics, with investigators tracing the extent to which a supposedly decentralized grassroots movement has been funded and steered by billionaires. The Kochs have been major funders of climate science denial and lobbying against regulation of the gas and oil industries. Theirs is by no means the only corporate family fortune deployed to steer national policy away from

anything that might disrupt unlimited profits. Not long after the BP spill—to pick just one such instance among many—the news delivered another report of fraud and insider trading charges brought by the Securities and Exchange Commission against two brothers in Texas, Samuel and Charles Wyly (Charles has since passed away), who made an estimated $600 million in unreported profits. The Wyly brothers were politically active on the right; for instance, they contributed generously to the "Swift Boat" campaign smearing presidential candidate John Kerry's war record. Their dealings were investigated for six years before charges were brought, and it will take more years to learn whether or not they are found guilty. Either way, there will be another such case next week or the week after that, in which people who would have a hard time spending the money they have already amassed will be called to account for insatiable appetites untroubled by such obstacles as law.

It has come to this: a seemingly inexhaustible supply of men who never have enough and will do whatever it takes to get more, regardless of the consequences for the rest of us; and a public sector that helps them do it.

To me these men symbolize both prodigious potential and terrible waste. Many individuals who rise to power in these systems are in possession of formidable drive, talent, and energy. Many are able to use their gifts in valuable and creative ways. I try to imagine what could have set them on paths less self-aggrandizing and less heedless of the consequences for others. But it's moot. Some switch has been flipped, and the deep desire that accompanies such abilities gets channeled into a type of wanting marinated in surplus aggression: more money, position, the power to dominate others. They may carry tremendous latent capacity to express and experience other types of desire—to be seen and see truly, to be loved for oneself, to experience the satisfactions that only come if one is willing to stand unmasked, risking extreme vulnerability. If they accept that those capacities cannot be expressed

in the world they inhabit, everything is channeled into acquisition and dominance until it becomes second nature. And instead of benefiting from the remarkable gifts such individuals could bring to public and private relationship, everyone affected by their actions suffers the consequences of their distortions.

If wealth really satisfied these corporate leaders, they would stop when they had enough to buy whatever they wanted. But without understanding that the source of their appetite is something broken in themselves and their culture, some past betrayal or deformity of character fed and bloated by a corporate culture that welcomes and creates ceaseless appetite, they will not stop.

T he culture of Corporation Nation damages its leaders, those who work for them, those affected by their products and policies, and through actions such as the BP oil spill, the very life of the planet. I want to focus now on the damage that emanates steadily from this culture, whether or not disaster occupies the foreground. I invite you to take part in a little thought-experiment.

Imagine that we're in a vast conference room high above a city, you and I, seated side-by-side. Light streams through floor-to-ceiling glass, saturating the melted-chocolate surface of a long conference table. Every person here, man and woman, is wearing a suit. Each of us sits in a cushioned, high-backed chair, drinks from a mug. As one, we gaze first at a PowerPoint presentation, then at a speaker who comments on a particular slide. Mostly, we listen, but when one of us has a question, we ask it politely, propelling our words through smiles that seem a little forced. Whenever people look the other way, some of us quickly check email or text messages on the smartphones in our laps.

Perhaps there's a controversy simmering in the background, a rumor that everyone knows but no one mentions. Perhaps a colleague is very

ill, or has recently passed away. Perhaps you are—perhaps I am—full of excitement about something I have seen or done, urgent memories of recent pleasure elbowing past the PowerPoint to fill the screen in my mind. Perhaps not: there is no visible sign either way.

What is the worst thing you can do in a conference room?

Cry. Mourn, moan, expose the pain you are feeling, and see how quickly you are ushered out of the room, perhaps forever.

The next worst?

Call attention, through action or comment, to the life of the body. Share what feels good or bad in the moment, what physical sensations are evoked by the experience; say where the sensation is located, touch or point to body parts. Listen carefully, and you will hear muscles clenching all around the room; but if you point it out, you will be the only one to do so.

The next worst?

Make reference to the spiritual dimension of your shared experience. Describe a moment of oceanic connection you felt as you and a colleague came to an important realization about a project. Share an insight from prayer or meditation; share an experience of the ineffable; share a question about the ultimate value of your enterprise. Watch the subject change at light-speed, then get ready for stifled laughter as you round a corner, for embarrassed silence and averted eyes.

There is very little danger—almost none, really—that most people will transgress these unstated rules. Knowing what is permitted and what must be suppressed is part of the price of admission to this conference room. This knowledge is so deeply internalized, so securely embedded in the corporate environment, that there is no need to explain it aloud. Everyone knows that there is much more to ourselves than may be welcome here. But how often do we consider what we and our colleagues (and all those we encounter) lose by filtering out so much of who we are?

Human beings exist simultaneously in physical, emotional, intellectual, and spiritual realms. We are at our best—our most powerful, alive, and fluent—when we allow ourselves to receive and transmit information in all four dimensions.

Are you alone reading this, comfortable in a private space? Perhaps like me, you've chosen some music to read by. Right now in my world, Otis Redding is singing "I've Been Loving You Too Long." There is something in the way his voice interacts with the friction of fingers on guitar strings that stirs an answering vibration in my body. Maybe you've placed flowers on a nearby table: I'm looking at a Phalaenopsis orchid in full flower. Its twin branches, shaped like tiny windswept cypress trees, are blanketed in pale blooms resembling their namesake moths. There is something about the way the laden stems rise above thick green leaves that fills my heart.

Perhaps, like me, you lift your eyes to a pleasing prospect. Out my window, the sun is bright, shadows deepening as the afternoon light elongates. In the wind, a dozen different trees bubble and fizz like green fountains, spraying light. Summer afternoons can be a little sad, the drifting-down sense of something on the wane, a *memento mori*. A scene flashes through my mind, the memory of running through the sprinklers on a hot long-ago afternoon, of sweet, dry air streaked with rainbow arcs of water, turning dust to mud.

All of this is information: sounds, sights, scents, and the feelings and memories they evoke. The words I read—the words I write—are carried on their drift.

Some people attribute suffering to desire. But for me, suffering is rooted not in wanting but in the belief that happiness is conditioned on keeping. For me, to live is to desire. When I hear and feel beloved music, even as it ignites and satisfies my senses, it arouses the wish to hear more. Every gaze at my orchids is delicious, like the first taste of a fine apricot as summer begins; every look fulfills and awakens desire for

more in a cycle that refreshes itself so quickly and subtly, it never ends. When these energies are allowed to flow freely, satisfactions balance desires in a continuous dance of enjoyment. When the circuit is blocked by prohibitions and punishments, balance is lost.

When human beings are aware and engaged in all realms, when we allow the flow of desire without distortion, we are aligned with Eros, not just in the narrow meaning of sexual love (although sexuality is certainly part of it), but in an expansive Platonic sense of the embrace of beauty and attraction in all things. Alive in all dimensions, we perceive an eroticized world. Our senses are heightened; we hear the music of speech as well as its words. Tastes, scents, and motions color our perceptions, adding layers of information to what is consciously communicated. We feel sounds as well as hear them. We are aware of our own emotional responses, and able to perceive others' feelings as well. Each gesture reverberates in all dimensions, enlarging meaning, arousing our bodies, feelings, minds, and spirits. We are able to meet the world's fullness rather than filtering it out.

In that integral state, perceiving an expanded reality, we connect more easily with others. Our words and gestures evoke and resonate with others' awareness. Our presence is felt. Creativity flows.

But when we put so much of our selves to sleep as the admission-price to a work or school environment, we suppress and sublimate a remarkable amount of the information otherwise available in our surroundings and from our own bodies. After a time, like the cave-dwellers of Plato's parable, it is easy to adapt to a diminished life, so that if we notice anything, it is only a vague loss, a vague emptiness. Accepting this denial of experience, we sacrifice so much: fully informed judgment, our capacity for imagination, the cultivation of empathy, free-flowing creativity, authenticity, presence. To be sure, there is much variation in style, tone, and climate from place to place in Corporation Nation. But certain characteristic expectations of workplace conduct and decorum

dominate our common culture. The suppression of the emotional, physical, and spiritual overflows the business world, saturating other institutional settings: education, medicine, social service, the law—nearly every sector.

Self-exile from beauty and awareness weakens and diminishes us. I have many years of experience assisting organizations as a consultant, and I have observed that those conditioned to this way of being are often unable to perceive their own feelings. In certain environments, the most common response to questions such as "How does that feel?" is "I don't know." This frightens me: how much capacity for awareness and choice is possible for someone who cannot even identify his or her own emotions and sensations? Those who cannot say how they feel cannot use feelings to gauge their responses to the choices life presents. They are likely to be easily led by someone with clear and strong intentions. Once they are inured to the constraints imposed in environments shaped by Corporation Nation, it is easy to remain powerless bystanders to actions they would not condone if in full command of their capacities. They are cut off from their deepest, truest selves. The consequences of surrendering so much power mount up: terrible things happen, and no one takes responsibility. More and more, people are afraid to think about what may come.

Like many artists, my relationship to business has been—to say the least—ambivalent. I've learned to live with a level of economic anxiety that drives my non-artist friends wild. I am thrilled when I have more money, but generally, when I manage to stockpile some, I use it to buy my own time. To me, control of one's time is the essence of freedom. I would rather grant myself that luxury now than postpone it until I've accumulated enough to retire, whatever that means for an artist. And my grasshopper attitude can even seem sensible when I see all around

me abstemious ants who've lost much of their retirement savings in various economic meltdowns.

While artists represent every segment of political opinion—think Ronald Reagan—most of us cluster on the left side of the aisle, where we can easily acquire the fastidious tendency to equate business in general with corporate predators in particular.

But of course, that isn't accurate. Markets are cultural artifacts, like other types of social organization, intrinsic to human society, appearing wherever we form communities. Trade is arguably the basis of culture, and markets are the most efficient and user-friendly way to distribute certain goods. The only real similarity between BP and a green energy company—say, a business that manufactures solar panels or converts engines to run on recycled cooking oil—is that both are businesses. The distinctions are legion, but to me, the most important difference turns on the values that animate their work. Nowadays, everybody pays lip-service to stewardship of the environment, even BP executives. In almost any room, when you ask for a show of hands from those who care for the Earth, every hand will be raised. But only some of those hands will dig into their own potential profits to invest in the practices that actually help to heal the planet. As more people with capital and business expertise enter socially responsible investing and underwrite social entrepreneurship, this may change. But it isn't going to change enough until there is recognition of the value of cultivating imagination and empathy in place of unbridled acquisition.

A huge gap has opened up between Corporation Nation's value system—in which the capacity to generate profit is an all-purpose success criterion—which has become our dominant value system, and our collective ability to apply the lessons of art to our present wicked problems and social messes. It affects all of us, but the dimensions of this gap become especially clear through an examination of how we do

(or don't) support the work of artists in the public interest, the group I have called an indicator species for social well-being.

For decades now, artists and advocates for arts funding have been trying to play by Corporation Nation's rules in pursuit of sustenance. They've repeatedly attempted to pour the vast personal and social importance of their experience into containers—into language, slogans, arguments, bar charts, and strategies—far too small to hold it. The result has been almost unbearable frustration at being unable to put their point across. After long exposure to the framework of understanding that insists on privileging material value and things that can be counted, weighed, and measured over all other forms of value, they have been reduced to making weak, even desperate arguments that do not do justice to the powerful truths contained in the experiences of the ineffable that set them on their paths in the first place.

About 30 years ago, mainstream U.S. arts advocates committed to a desperation strategy focusing on justifying arts expenditure through weak economic arguments and secondary benefits. Facing threat, chameleons change complexion to convince predators that they're really just oddly shaped leaves. Just so, many arts advocates abandoned the importance of free expression, the personal and social need for beauty and meaning, and the social value of cultivating our intrinsic human desire to create, focusing instead on convincing opponents that art is really a clever strategy for raising test scores and tax revenues.

Mozart is good for babies, they said. Kids who play in the school orchestra are less likely to drop out—there's no separating cause from effect here, as those whose parents have more education are both less likely to drop out and more likely to join the orchestra. Mainstream advocacy groups have spent vast sums trumpeting the "economic multiplier effect," in which every dollar spent on theater tickets generates more dollars on parking and restaurants, multiplying jobs and taxes. This is true, as far as it goes. But the arts have no special claim: buy tickets to a dog show or nude lady mud wrestling and you get the same result.

At every arts advocacy workshop, experts advise modeling advocacy strategies on the personal styles and practices of legislators and corporate executives. How's that working out? There has been a decline of well over half in the real value of the National Endowment for the Arts' budget since Ronald Reagan took office more than 30 years ago: Fiscal Year 2012's NEA budget was $146 million, but it would have had to be more than $400 million just to equal the spending power of 1980. In my home state of California in 2000, more than one million students were enrolled in school music programs. By 2010-11, that number had dropped to 470,000.[65] And in that time the state's population rose by 10 percent.

Accepting the terms of the debate as primarily economic has made it unwinnable. By now, every arts advocate has been to a zillion briefings and absorbed a gazillion pointers on how to argue for the arts' economic impact, on the principle that getting the numbers right will be the golden key to public funding. Occasionally, I still meet someone who thinks that after all this time, the problem is that we still haven't discovered exactly the right charts and graphs to hit the jackpot. But on this point, we truly do have enough data: it is intrinsically impossible to justify public investment in creativity using these tools, because art's essence is its ability to engage us fully in body, emotions, mind and spirit, to create beauty and meaning, to cultivate imaginative empathy, to disturb the peace, to enable grief in the face of loss and hope in the face of grief. Trying to explain or demonstrate this with numbers is like trying to describe a rainbow without mentioning color.

It is ineffective, discouraging and unworthy of who socially engaged artists really are to keep trying the same failed approach over and over again. When—having been told there is no alternative—artists force themselves to impersonate corporate operatives one more time, their

65 California Department of Education, Educational Demographics Office, http://dq.cde.ca.gov/dataquest/CrseList1.asp?cYear=2010-11&cChoice=StCr se&cTopic=Course&cLevel=State&myTimeFrame=S&Self=&Subject=on&A P=&IB=&VE=

trying can't help but turn half-hearted because it falsifies what they actually know. The artists and advocates who press on with this failed strategy have been distracted from the memory of their own awakening, from what their experience has to offer countless others. When I speak to groups of artists, I ask if they would really be doing what they are today if the strongest reasons for doing it were the economic impact of people buying theater tickets on restaurant and parking-lot revenues. They laugh at the question's absurdity. I ask if they would really be doing what they are today if its most significant impact was documented in research results so flimsy it is impossible to distinguish cause from effect: do music lessons affect dropout rates, or are the children of parents who push music lessons less likely to drop out for other socioeconomic reasons? They laugh again, but with a bitter edge, seeing how easy it is to normalize absurdity.

No matter how you run the numbers, it has become clear that for artists, the strategy of impersonating corporations is a failure. A key reason that it fails is that it is conditioned on the constrictions of Corporation Nation rather than asserting the fully dimensional understanding of the human subject illuminated by art.

In reality, the cumulative result of millennia of human creativity embodied in art-making is a repository of wisdom, social imagination, empathy, beauty, and meaning that is essential to surviving the crises our society now faces. It sustains us through difficulty and inspires us to make change. It provides the vessel, the matrix, for all human knowledge. And right now, we really need to get to know each other. We need to share our stories and dream together how to change the big story of our collective fate. We need the skills of imagination, improvisation and renewal that can be learned more fully and deeply through art than by any other means. And the people who have made art our life's work need to be able to express, embody and convey these truths without hesitation or embarrassment.

When I see the dominant arts advocacy strategy enacted, I think of Hans Christian Anderson's tale, "The Emperor's New Clothes." It is actually based on a much older fable that emerged from the ferment of Arab and Jewish culture in medieval Spain. In the original, the con artists responsible for the emperor's costume say that the clothes are invisible to anyone who is not actually the child of his or her father, intensifying the social pressure to see more than a naked man. Anderson lightened the story a bit, recognizing that general peer pressure would suffice to silence most people. When you are told over and over again that what you know to be true is just your imagination, you start to take that doubting voice into yourself, you start to hear its echoes whispering in your own ear even when no one else is around. You start to believe its whispers more than the evidence of your own body, emotions, mind and spirit, like the courtiers in the tale of the emperor's new clothes. You begin to lose the courage of your convictions.

There is a delicious relief in stepping into a way of understanding and speaking about the public interest in art that is fully commensurate with the truth. Our power to persuade is at its height when there is absolute congruence between what we know and what we say. Yet often, when I ask audiences of artists and advocates to imagine themselves making this change, intense anxiety arises.

I invite them to reflect on its source. The great Brazilian educator Paulo Freire contributed tremendously to our understanding of these dynamics, describing how we are persuaded to internalize self-defeating messages, how easily we come to mistake them for our own ideas and feelings. He described a phenomenon called "fear of freedom," in which people are afraid to abandon beliefs that no longer serve them, because the prospect of living without them creates too much anxiety, and often because they have been persuaded there is nothing to believe in their place. Corporation Nation's pressure to conform to its value system and mores is steady and intense. When artists and advocates consider

letting go of the old arguments for the arts, the ones that have failed over and over again despite steadfast loyalty, a voice arises to say, "We can't abandon the way we've been doing it for all these years! We'll be defenseless!" But of course, they are already defenseless, having tethered their fate to failed strategies. The great likelihood is that more powerful and true arguments will emerge when they have cleared out the old, impacted, disabling beliefs that stand in the way of bringing their full gifts and full social imagination to the task.

We have a good deal to learn from spiritual traditions about how to do this, especially because every wisdom tradition offers stories about standing for the truth against even the most powerful opponents. I like the way Rebbe Nachman of Bratslov, the great 18th century teacher, put it: "A person needs holy arrogance, holy *chutzpah*. He should be bold as a leopard against the people who are preventing him and mocking him. He shouldn't subjugate himself before them, and he shouldn't be embarrassed in front of them at all." I've had some amazing discussions with powerful people that started by asking them to remember one of the first works of art—a song, a book, a film—that moved and inspired them to see the world differently, even in some small personal way. Our interactions with such people tend to be constrained by social roles: all the players know what they should say, repeating their prescribed lines dutifully. Showing up as oneself is the alternative. I ask artists and their advocates this: what have you got to lose? Other than illusions, nothing.

During the whole period that artists and advocates have been imitating corporations in an attempt to win funding, the organized right in the U.S. has used arts funding as a handy weapon to attack any moderate or liberal administration. As I described earlier, it worked in the 1990s when the American Family Association and its allies besieged the NEA for supporting Andres Serrano, Robert

Mapplethorpe, and filmmaker Marlon Riggs. A moral panic was raised, grants and agency budgets were cut, and the right-wing advocacy groups steering the campaign raked in unprecedented donations. The strategy has proven evergreen.

Not long after President Obama was elected in 2008, Fox News' deranged commentator Glenn Beck set out to attack the administration by condemning the positions and associations of key members. Emboldened by his victory in forcing Van Jones to step down as Green Jobs Advisor, Beck and his ilk fixed their sights on activist artists and on public arts agencies such as the NEA. They forced the resignation of an NEA staff member who had been involved in promoting President Obama's United We Serve volunteer campaign, denouncing it as an attempt to politicize arts funding. They pored over notes and recordings from every arts-related meeting and memo at the White House, and managed to make a multi-course meal out of the crumbs they discovered. It doesn't take much to create a tempest. When the ideologues of the right want to bash a liberal administration, it is always handy to pick up the same club, the National Endowment for the Arts, a minuscule federal agency with a budget amounting to a few cents per person. Why?

It's an efficient form of political speech, as I've already mentioned, garnering lots of budget-cutting publicity without offending powerful constituencies or risking much budgetary impact. But there's more. Whether through intuition or analysis, the right understands that the way we craft our stories shapes our lives and collectively, our society. While Democrats and progressives tend to see artists as nice but unnecessary to real democracy, the right sees artists more clearly, as in possession of powerful skills of expression and communication, most often in the service of freedom, equity, diversity, and inclusion. They understand that creativity and public purpose are a potent combination. They want their story—that the United States belongs to white Americans who think as they do, and that their ownership confers the right to exclude, discredit

and scapegoat others by any means necessary—to predominate, and so they are willing to do anything to disrupt the counter-narrative of art and public purpose. Racism is one animating force behind each new round of scapegoating; another is the invidious prejudice against artists as exemplars of freedom in action. In media blowhards' arsenal, artists have long been a weapon of choice.

They also pick on artists and their supporters because based on past experience, they are counting on those in power not to fight back soon, or hard, or with much conviction. In the U.S., we are sadly used to seeing public officials surrender at the first shot across the bow, sacrificing free expression in the hope of preserving their own positions. In the late 80s and early 90s, the NEA responded to smears by abandoning the programs that had been targeted; in 2009, the NEA fired the staffer targeted by Glenn Beck.

Our predicament is stark: our common culture feels the heavy weight of corporate hegemony, a lumbering Gargantua trampling the forest underfoot.

The damage may be assessed in many ways. In a July, 2012, interview with Bill Moyers, the journalist Chris Hedges spoke at length about capitalism's "sacrifice zones," referring to "areas that have been destroyed for quarterly profit…environmentally destroyed, communities destroyed, human beings destroyed, families destroyed."[66] He was speaking of places on the land such as the coalfields of southern West Virginia, where local people have been unable to halt the destruction of their environment and livelihood by extractive industries keen to profit at all costs.

Just so, there are sacrifice clusters within the populace. These people don't all live in the same place, but they occupy a common niche. I'm

66 http://billmoyers.com/episode/full-show-capitalism%E2%80%99s-%E2%80%98sacrifice-zones%E2%80%99/

not asserting a hierarchy of sacrifice that says socially engaged artists are hardest-hit. But because they are an indicator species for social well-being, their sacrifice status is emblematic. Those who know most about creativity in the service of democracy, about the cultivation of social imagination and empathy—and who therefore have the most to teach about the emergent reality that can and should supplant Corporation Nation—are treated as dispensable and starved of resources while untold sums are poured into war, environmental plunder, the conversion of social goods to private profit, and the transfer of wealth to an oligarchy.

It isn't that channeling resources to these artists would magically topple Corporation Nation. But re-understanding their social importance as bearers and stewards of cultural vitality and investing in them in the context of a national program and cultural policy driven by deeply democratic values would affect and engage individuals and communities across the population, cultivating the self-awareness and social awareness that can release Corporation Nation's grip. This isn't about artists per se, but artists as a leading wedge of an encompassing change. The actions taken to bring artists' approaches and skills to bear on our cultural crisis can inspire and catalyze change throughout other sectors (as the prior section, "Hidden in Plain Sight," attests).

What, then, is needed to accomplish this?

A paradigm shift is not a ten-point program. It is a radical revision of a model of reality, changing the meaning of all that we see and do. Elsewhere in this volume and at the companion page on my website (cultureofpossibility.net), I links to ideas and actions that can help. But what will help first and foremost—what precedes any useful program of action—is to radically renew our idea of the public interest in art.

In the old model, culture is soft in contrast to the hard things that are seen to make history, especially the tracks that militaries, money, and

manufacturing make as they move through time. Art is dessert, a luxury that can be suspended when more important matters beckon. Culture is an abstraction, nothing more than a mirror allowing the powerful to burnish their reflections and the marginalized to eke out consolation in the hope of softening their losses.

In the new model (which subsumes the many stories I tell in this book and in the companion volume, *The Wave*), culture moves to the center of attention. It is the crucible in which a livable future is forged. In the crucible, we work out identity, connecting to community and to our own deepest meanings, gravest fears, and most daring dreams. There, we shape the empathy and imagination that inspire us to try to live by The Golden Rule, to glimpse the moral grandeur of which human beings are capable. Our lives are suffused with beauty and meaning, and instead of being constrained to narrow roles—consumer, employee— that exclude so much of our vast human potential, we can live as fully dimensional human beings.

Because culture is the lever that actuates change, in making this shift in understanding, ends are indistinguishable from means. In both what we do and how we do it, we have the opportunity to break the enchantment of a distorted and self-serving narrative that has acquired an air of permanence; we have the power to represent a deeper truth in its place. This requires a fearless calling-out of Corporation Nation wherever its negative impacts are seen and felt, and an unshakeable refusal to be cowed by cries of "class warfare" or any other attempts to silence dissent. It also requires a forthright, unabashed declaration of the public interest in art, and a total rejection of the pressure to bow to the trivialization and ridicule sure to issue from guardians of the old order.

To succeed, this new knowledge has to suffuse daily reality and self-understanding. It's not like adding patches to a suit of old clothes, but tailoring and dyeing garments into a markedly different shape and color, saturating the old social fabric with a brand-new hue. Imagine the same

double-barreled message—ending the dominion of Corporation Nation, declaring the public interest in culture—carried through ordinary conversation, professional dialogues, works of art, policy debates, critiques of conventional wisdom, planning for the future—indeed, through all we do. To succeed, that feat of imagination must be practiced, then infused throughout the body politic.

The operative verb is *enlarge*. The public interest in culture has outgrown all the old boundaries. "Do you like it?" or "Is it good?" or the question that subsumes both of them, "Is it art?" The notion that these are questions of anything more than personal taste has become ridiculous. We need to hold the entire cultural landscape in our field of vision without being constrained by the old categories of discipline, style, or period, by whether something is conceived as for-profit or non-profit, or by the professional bona fides of those who make art. The task is to enlarge our understanding of culture such that all that is made and done to express identity, community, fear, or aspiration through voice, image, movement, and other creative means is seen as part of a vast tapestry, every bit of which has meaning and value. The challenge is to enlarge our collective understanding of culture's value as a guide to social meaning, the container for an era's thematic universe, and therefore a ground for interventions that can profoundly affect that universe. The opportunity is to enlarge our awareness of art as our lingua franca, the system of signs and symbols through which we convey our urgent news and deepest meanings.

When a new awareness dawns, everything starts to change. Remember the old mnemonic for journalists: who, what, when, where, why? Just the facts? Even when traveling in the microcosm, dealing with interpersonal experience in the realm of private life, understanding the centrality of culture inspires us to begin asking different questions when we seek to decode experience:

How does it feel? Where do you feel it in your body? Can you describe the emotions, the sensations? When you tune in, how does your body want to move?

What does it remind you of? When you close your eyes, is there a scene or story that comes to mind? Have you known this story before?

What sounds are evoked? If this moment or situation had a soundtrack, what music would you hear?

What shapes and colors are evoked? If you drew or painted this moment or situation, what would it look like?

How might the person across from you answer these questions? What can be discerned from the differences?

How can you imagine this story changing? What might it take to actualize that change?

The people who know most about how to ask these questions, how to listen deeply and allow the answers—or just as often, the new questions they evoke—to resonate, affecting all involved: those people are artists, and they have critically important roles to play as midwives of the new paradigm.

The conventional shape for a book of social critique—especially one that focuses on wicked problems and social messes—includes multiple chapters detailing problems that seem overwhelmingly complex and intractable, followed by a zippy conclusion proposing a set of solutions that readers almost always find vastly overbalanced by the problems they purport to solve.

Often the proposed solutions turn on stopping something bad from happening. Typically, it is easier to focus on how to prevent or forbid something than to enable or catalyze a new something in its place. So when we think of social transformation, especially the changes that are

needed to raise the general level of practical justice and compassion, it is easy to think of constraints: new regulations and laws, new penalties to strengthen existing laws and policies created to prevent abuse. We think of punishing wrongdoers, and of course, sometimes these things are necessary. Thomas Hobbes was almost certainly right, that a society without laws degrades to *Bellum omnium contra omnes*, the war of all against all.

It also strikes me that part of the reason our society goes so quickly and reliably to broad and punitive public responses is that many of us are by now cynical about positive transformation. Gazing at the foxes in charge of our economy, for instance, and it is hard to imagine them emerging as fully dimensional human beings, willing to face their own vulnerabilities and allow their formidable talents and desires to manifest organically, rather than power-packing them into forms of aggression. It is difficult to conjure a plausible imagination of the many individual transformations that would be needed to radically revise these systems.

Instead, it is tempting to start at the top, with huge public initiatives designed to enable sweeping change. Often, then, because they seem unlikely to come to pass under current political conditions, advocates retreat to believing that very little is possible, shrinking their hopes as an inoculation against disappointment. Each grand failed experiment only reinforces this skepticism: the people who invented programs like No Child Left Behind genuinely believed that systematizing education, with test scores driving value just as market numbers drive Corporation Nation, would make things more efficient and productive. Many did not foresee the extent to which the culture of competition they were feeding would have the opposite effect (the law of unintended consequences being virtually the only one consistently obeyed). Education expert Diane Ravitch, who praised George Bush for the original legislation, changed her mind after seeing it in action:

"The basic strategy is measuring and punishing," Ravitch says of No Child Left Behind. "And it turns out as a result of putting so much emphasis on the test scores, there's a lot of cheating going on, there's a lot of gaming the system. Instead of raising standards it's actually lowered standards because many states have 'dumbed down' their tests or changed the scoring of their tests to say that more kids are passing than actually are."[67]

So yes, there are policy initiatives and schemes I'd like to see enacted. They are threaded throughout this book: giving culture standing in public and private actions, so that it isn't so easy to sacrifice social fabric for private profit; infusing social goods with the work of artists, so that we rely on collaborative creativity rather than top-down edicts to move people toward social goals and ease their way through social systems; establishing equity in cultural funding, undoing the tilt toward red-carpet and commercial arts in favor of a pluralistic and equitable system.

Through a lifetime of activism, I've proposed, agitated, argued, and lobbied for these things without anything resembling substantial success. A few vignettes:

In the early 1970s, I was the lead organizer for something called the San Francisco Art Workers' Coalition, a loose alliance of young, diverse artists dedicated to accountability in local cultural funding and policy. One of our goals was to ensure that publicly funded cultural institutions were responsive to, and representative of, the communities they served, to the taxpayers who underwrote their work.

Our linchpin campaign turned on the exhibition at the publicly funded de Young Museum of John D. Rockefeller III's collection of American art, timed to coincide with the bicentennial of the American Revolution in 1976. Charting out the economic and social relationships of the museum's board members yielded a diagram of conflicts of

67 On National Public Radio's "Morning Edition," 2 March 2010. http://www.npr.org/templates/story/story.php?storyId=124209100

interest as dense as a spider-web. The institution may have been publicly accountable according to the letter of the law, but in spirit, it was run like the private preserve of the city's richest and most powerful families.

JDR III had amassed his collection at bargain prices, and was then donating it to an institution that would preserve and inflate his "brand" by building a handsome and expensive new wing to house the collection. One of our complaints with the bicentennial exhibit was that by valorizing an all-white, all-male art collection as representing America's best, it repeated the same sin against democracy that the city had committed in putting an all-white, all-elite Board of Trustees in charge of a public cultural trust.

We had meetings and public forums, published studies and calls for reform, handed out flyers at the museum's front door. Finally, we were permitted to address the Trustees. As always, the meeting was held in a museum room lined with glass vitrines holding fine porcelain. After the presentation, one of the museum's curators took me aside.

"The Board isn't going to let just anyone join," he told me confidingly. "But they'd be comfortable with someone like you. Didn't you go to one of the Seven Sisters?"

I had to look it up; I hadn't heard that expression before. I learned that it referred to a group of elite Northeastern women's colleges founded in the 19th century. I hadn't gone to college at all. In my personal pantheon of life-lessons, this stands out as an especially instructive experience, offering me a clear glimpse of class prejudice, its easy assumption that qualities such as intelligence and articulateness were attributes of privilege. Politically, it showed me what I was up against. Although the members of our Coalition worked hard for progressive politicians and were rewarded with declarations of support for our cause, in the end, no official would risk offending major donors by questioning their right to reign over the city's cultural life.

More than 30 years later, in the run-up to President Obama's 2008 election, many of my friends and colleagues became excited by a notion that was being bandied about, that Obama could be something like a modern-day Franklin Delano Roosevelt, ushering in a version of the New Deal, with public investment in social goods and infrastructure to help balance marketplace excesses. I'd been calling for a "newWPA"—a new public-sector job-creation scheme employing artists in public institutions and community settings—since the Art Workers Coalition days, when hundreds of social engaged artists showed up to apply for the first few such jobs made available under the Nixon-Ford–era Comprehensive Employment and Training Act. I wrote several long and much-quoted essays proposing a new equivalent of FDR's Works Progress Administration, suggesting how it might work, offering ways to transition toward it by redeploying parts of existing federal programs. Early in President Obama's first year, I helped to organize a delegation of socially engaged artists to the White House, where we still hoped our idea would be received with interest.

At this writing, President Obama's second term has begun and we've been through four years of a Democratic administration plagued by epidemic unemployment, with no serious investment in public-sector job-creation even being proposed by the President. In the present climate of Corporation Nation, no mainstream elected official will risk the ire of Republicans by openly advocating such a thing. The challenge for people like myself is to try to help keep the conversation alive, knowing that even successful policy proposals often take long years to move from the laughably unrealistic to the feasible. A miracle is always possible, but I doubt this one will come anytime soon.

In short, under present conditions, I don't see the value of attaching too firmly to a specific public program idea or piece of legislation which—if it fails—can easily be perceived as invalidation of the underlying ideas, rather than merely a barometer of anemic political courage and wisdom.

I think our best hope is to cultivate individual awareness, spread ideas, create excitement and stimulate private-sector initiatives that can gather energy and bubble up into the public sector. I'm counting on you to see it, speak it, remember it, and over time, infuse it into our collective understanding. I'm counting on you to effectuate the paradigm shift.

How do you start? I suggest music. I have found that a conversation is never less than expansive, riveting, and enlightening when it starts with this request: *Tell me about a piece of music you listened to over and over when you were young.*

I started this section of the book with a journey through my neighborhood viewed through multiple lenses, including one that perceives cultural meanings hidden beneath the surface of everyday life. I want to end it with another type of journey. If you have access to recorded music, take a moment to cue up Van Morrison's "Astral Weeks" before you go on reading.

The music you are hearing is the first track on Van Morrison's second solo album, released in 1968. For most of my adult life, *Astral Weeks* was my desert-island album (it may be still, although *John Coltrane & Johnny Hartman* may have supplanted it).

That concept may be a stretch today, when no self-respecting music fan would be caught on a desert island or anywhere else without a vast library of music encoded on something the size of a credit-card. But back in the day, it was a sort of getting-to-know-you party game: what book, what recording, what else would you choose if you were marooned with only one of each? The last time I played that game was at least a dozen years ago, sitting around a table of independent filmmakers. Of the eight men and women present, three picked *Astral Weeks*, and one of them was a man half my age.

More than forty years on, and I'm still not tired of listening to this music. I think that's because it expresses the artist's sensibility in such unique and satisfying fashion: intricate, nostalgic even on first hearing, lyrical, driving, passionate, evocative, unbound by the conventions of its day. Each time I listen to *Astral Weeks* late at night or on a walk by the water, it reminds me of all the other times I've invited that music to twine itself around my heart and mind, to infuse my body and spirit. It takes me to higher ground. It reminds me of who I have been and who I am.

It also evokes a period of my life that was incredibly rich and exciting—something like the present moment, in fact—not only because I was young, but because the *Zeitgeist* was so heady in those days, you could get a contact high just breathing it. Unlike most other recordings that I own, I can tell you the exact day that I acquired *Astral Weeks*. It was presented to me as a gift on December 6, 1969, on the way to the Rolling Stones' famous free concert at Altamont Speedway in the Northern California hills east of the Bay Area. The Hells Angels motorcycle gang was hired to provide security, for which gang members were compensated with $500 worth of beer. During the Rolling Stones' set, Hells Angels killed a methamphetamine-crazed fan who'd approached the stage waving a revolver. That event was captured for the Maysles Brothers' documentary, *Gimme Shelter*.

I wasn't close to the stage when the deed went down, but in a long day of bad vibes, I'd seen people who were wrecked on jug wine and speed get into countless fights. Altamont was only four months after the vast peace and love-fest of Woodstock, yet looking around, we all knew that something had changed. In the space between *Astral Weeks* and the Stones' "Sympathy for the Devil" (the tune playing while Meredith Hunter was stabbed), a question about the future opened up. I chose an answer emanating from the integral vision of *Astral Weeks*.

Virtually everyone has a personal stock of stories like this: music that moved me, music that reminds me, music that—when heard again, even

at decades' remove from the original association—recreates another world, drawing remembered ideas, emotions, physical feelings, and spiritual states into the present, submerging us in sensation.

Take a moment to change your soundtrack to Sam Cooke's anthem, "A Change is Gonna Come."

My most important personal epiphany of the last few years came when I understood that my task wasn't to convince people of art and culture's centrality to our collective future, but to show how that assertion had already been proven. The problem was that not enough people had yet perceived the shift to reach a tipping-point of general awareness.

The story goes that Sam Cooke was inspired to write "A Change is Gonna Come" by hearing Bob Dylan's "Blowin' in The Wind." It impressed him as an especially profound statement from someone who had not experienced the pain of segregation directly, thus strengthening Cooke's resolve to speak out through his own music. This was at some risk to his success: Cooke was an early crossover artist whose fans were mostly white. His sweet, mellow voice and face were packaged to telegraph a non-threatening, "all-American" image reassuring to white record-buyers. But this song was different from his prior hits: it braided the pain of racism's persistence with the yearning for change, without shortchanging either. "A Change is Gonna Come" expresses the mingled hope and despair, the bipolar state, of anyone who seeks significant social change:

There have been times that I thought
I couldn't last for long
But now I think I'm able to carry on

It's been a long time, but I know
A change is gonna come, oh yes it will

We tend to think of change as catalyzed by action, and of course, that is one undeniable truth. If you are fighting wicked laws such as legal segregation, then people's willingness to break those laws—to

risk their own well-being—stirs conscience, adding force to the court-cases and legislative battles that can overturn them. But awareness and perception have a great deal to do with it too. Racist behavior harms those discriminated against most of all, but it also deforms the lives of racists, whose capacities for empathy and imagination are impaired by their repugnant beliefs. Unable to imagine those they vilify as full human beings—as equals, friends, family members, loved ones, or superiors—they are unable to feel compassion for the pain they inflict. Lasting change is only possible with a renewal, a reshuffling, of awareness and perception.

"A Change is Gonna Come" was released in 1964. A trip to the deep South in 2013 will still reveal racism, of course—so will a trip around the block, wherever the block happens to be. But if Sam Cooke (who was killed in December, 1964) were to retrace his steps today, he would be astounded to see the many interracial couples and families, the multi-colored workplaces and schoolrooms, the degree to which the general perception of possibility between the races has changed. One of the precipitating incidents that led Cooke to write this song was his band being turned away from a whites-only motel in Shreveport, Louisiana, in 1963. Shreveport's first African American mayor, Cedric Glover, was elected in 2006, after serving on the Shreveport City Council and in the Louisiana House of Representatives, and re-elected in 2010—unthinkable possibilities, it is safe to assume, to the people who denied Sam Cooke a bed for the night.

Cooke's song has been recorded many times, earning its place as an enduring civil rights anthem. It was especially visible during the years my own understanding of the paradigm shift took full shape. Barack Obama alluded to it in his speech to supporters on election night 2008: "It's been a long time coming, but tonight, change has come to America." As part of the social change-oriented global music project called "Playing for Change," a group of street musicians from the U.S.,

Europe, and Africa released a recording of the song in 2008. It was also a hit in 2008 for the British-Nigerian singer Seal who (especially once he married the German supermodel Heidi Klum) became an avatar of postmodern racial signifiers.

When they hear the song's title (or even an allusion to it), many millions of people can also hear this music in their heads. They can repeat the words or approximate the tune. But what Cooke's song really evokes is the complicated mix of frustration, desire, and hope of fulfillment that signifies humanity's long journey between oppression and equality, still incomplete. In a little over three minutes, it elicits a remarkable range of somatic, emotional, intellectual, and spiritual associations. It doesn't so much tell a story as allow us to experience that story unfolding within our own bodies and imaginations. Recognizing and understanding that power is what this book is about.

What song is spiraling through your heart and mind right now? How does it feel? Where do you feel it in your body? Can you describe the emotions, the sensations? When you tune in, how does your body want to move? Everything depends on giving this experience its full weight. Go ahead: before you close this book, ask another person this question and practice standing for art's public purpose and power, one step at a time.

Index

About The Author

Arlene Goldbard is a writer, speaker, consultant and cultural activist whose focus is the intersection of culture, politics and spirituality. Her blog and other writings may be downloaded from her Web site: www.arlenegoldbard.com. She was born in New York and grew up near San Francisco. Her book *New Creative Community: The Art of Cultural Development* was published by New Village Press in November 2006. She is also co-author of *Community, Culture and Globalization*, an international anthology published by the Rockefeller Foundation, *Crossroads: Reflections on the Politics of Culture*, and author of *Clarity*, a novel.

Her essays have been published in *Art in America, Theatre, Tikkun, Teaching Artist Journal*, and many other publications. She has addressed many academic and community audiences in the U.S. and Europe, on topics ranging from the ethics of community arts practice to the development of integral organizations. She has provided advice and counsel to hundreds of community-based organizations, independent media groups, and public and private funders and policymakers including the Rockefeller Foundation, the Independent Television Service, Appalshop, WomenArts, the Center for Digital Storytelling, and dozens of others. She serves as President of the Board of Directors of The Shalom Center.

The Culture of Possibility: Art, Artists & The Future was published simultaneously with a companion work of fiction on art's public purpose, *The Wave*.